THE GRAY'S ANATOMY
COLORING BOOK

The GRAY'S ANATOMY
COLORING BOOK

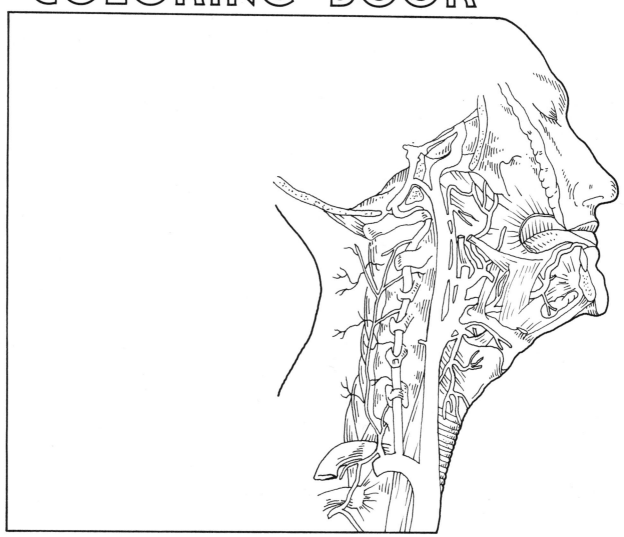

Reproduced by Gail Potamkin
Text by Matthew V. DeCaro

Running Press
Philadelphia, Pennsylvania

Canadian representatives: John Wiley & Sons Canada, Ltd.
22 Worcester Road, Rexdale, Ontario M9W 1L1

International representatives: Kaiman & Polon, Inc.
2175 Lemoine Avenue, Fort Lee, New Jersey 07024

9 8 7 6 5 4 3 2

Digit on the right indicates the number of this printing.

LIBRARY OF CONGRESS CATALOGING IN PUBLICATION DATA

DeCaro, Matthew.
 Gray's Anatomy coloring book.
 Contains 102 ill. from Anatomy, descriptive and surgical, by H. Gray published by Running Press, 1974.
 SUMMARY: Drawings of the human anatomy are accompanied by explanations and are designed to be colored in.
 1. Anatomy, Human—Pictorial works. 2. Painting book. [1. Anatomy, Human—Pictorial works. 2. Body, Human—Pictorial works. 3. Coloring books] I. Gray, Henry, 1825–1861. Anatomy, descriptive and surgical. II. Title.
 QM25.D42 611 80-11665

ISBN 0-89471-103-2 paperback
ISBN 0-89471-102-4 library binding

All graphic references in this book are from the Unabridged Running Press Edition of the American Classic Gray's Anatomy.

Design by Claire Owen
Cover illustration by Suzanne Clee
Cover photography by Carl Waltzer
Cover art direction and design by James Wizard Wilson

This book may be ordered directly from the publisher.
Please include 50 cents postage.

Try your bookstore first.

Running Press
38 South Nineteenth Street
Philadelphia, Pennsylvania 19103

INTRODUCTION

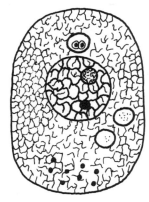

Diagram of a cell.

What is anatomy? For most people, the word conjures up recollections of dissection exercises in high school or college biology labs, or images of medical students laboriously memorizing the names of an astounding number of muscles, bones, and blood vessels. And while those pictures are true to the simple definition of anatomy—the study of the structure of living organisms—they don't convey the excitement and sense of discovery that come when you see laid out before you all the marvelous systems and structures that make up the human body. You don't have to be a medical specialist to share this feeling; it's open to all of us, from children just beginning their studies to adults who've left their school books far behind. And what better way to discover the wonders of anatomy than by paging through—and coloring in—a selection of drawings from *Gray's Anatomy*, the classic reference book in the field.

Reproduced in *The Gray's Anatomy Coloring Book* are over a hundred adaptations of the original illustrations, accompanied by descriptive captions. In order to make your coloring easier, the labels on the drawings themselves have been kept to a minimum, and the terminology has been limited to the basics. In a number of the drawings, dotted lines have been superimposed on some of the bones; these represent areas where specific muscles are attached. But enough of the details. This is, after all, a coloring book—a book designed to give you a chance to learn about the human body and have some fun at the same time.

When you're working in *The Gray's Anatomy Coloring Book*, you can choose any color, or combination of colors, that pleases you—but the odds are that if a pathologist found some of these colors in your body he'd be far from pleased! That's because the color of the organs in the human body provides important clues about the presence of disease. For example, a yellow liver is full of fat, a red liver is full of blood, and a green liver is full of bile—and some livers are even multi-colored!

Most of the internal organs in your body are normally colored in shades that range from tan to pink. The liver and spleen are purplish-brown, the adrenal glands bright yellow, and fatty tissue a slightly less intense shade of yellow. The outer rim of the brain is light gray (hence the term "gray matter"), while the inner portion is practically white. Blood, of course, is red, and because the blood in the arteries has a higher oxygen content than that in the veins, it's a lighter shade of red—those veins you thought were blue only seem to be that color because you're looking at them through your skin.

Of course, it's handy to know these normal ranges of colors, the shades that a doctor will be looking for, but that's no reason why you should feel obliged to stick to them in this book. If you want a green spleen, you can go ahead and have one, without checking into the hospital or even suffering the slightest discomfort! *The Gray's Anatomy Coloring Book* is the perfect place to express yourself—and if picking out colors for your own internal organs doesn't add a whole new dimension to your notion of self-expression, then maybe you ought to be checked out by your doctor after all!

—*Jay F. Schamberg, M.D.*

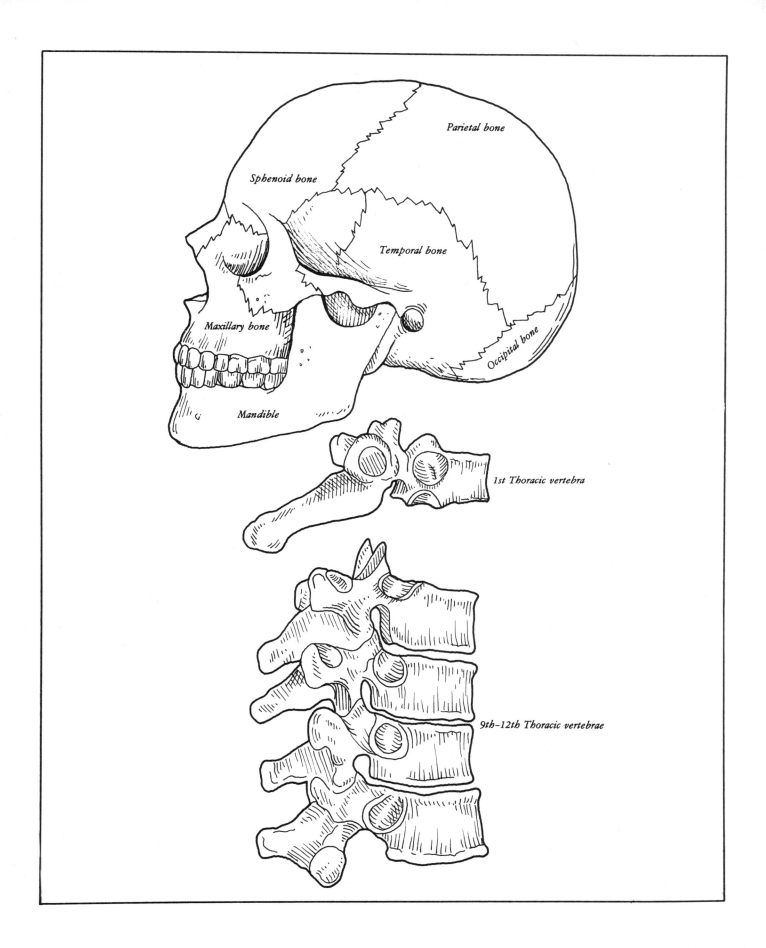

Top: A side view of the skull showing its major bones. *Bottom:* Segments of the backbone in the chest, or thoracic, region. These are the thoracic vertebrae.

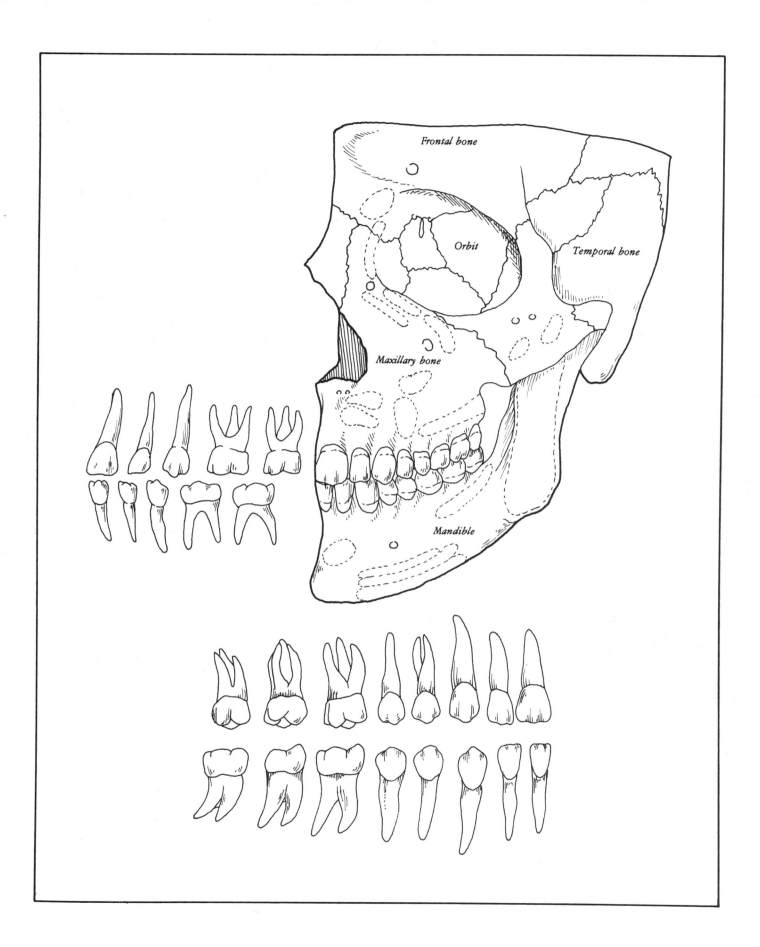

Here we see the left side of a skull showing the major bones that make it up. The sets of teeth shown apart from the skull are, on the top, the first, or "baby," teeth; and, below, are the permanents.

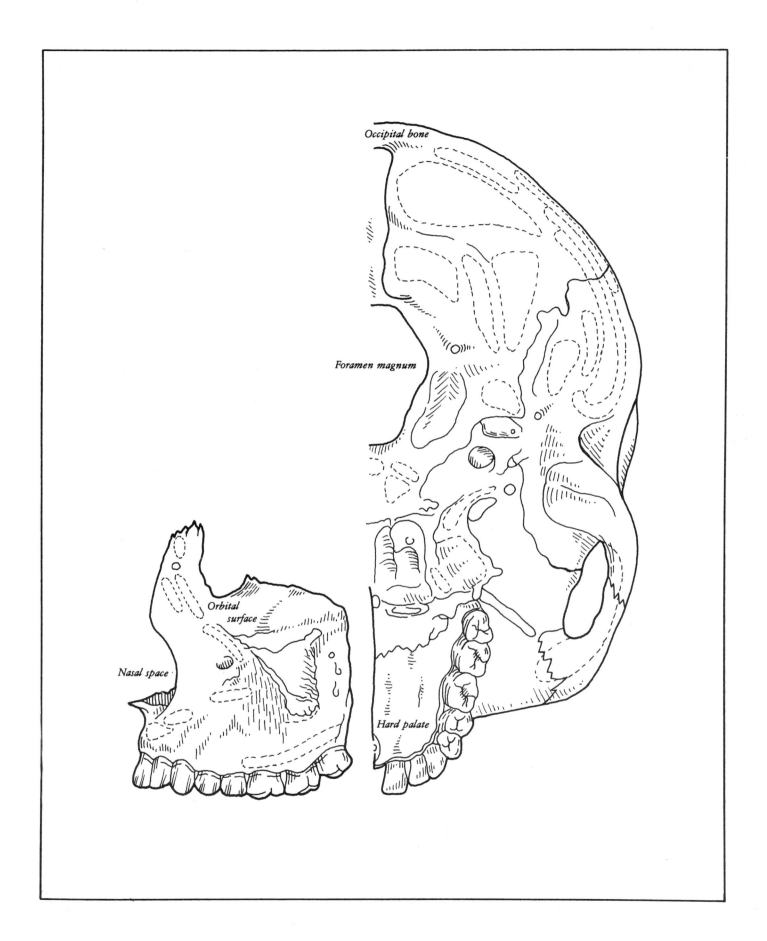

Left: A view of the maxillary bone, part of the upper jaw formation, separated from the rest of the skull. *Right:* The base of the skull. The large hole (foramen magnum) is for the spinal cord. The numerous other holes and ridges are where nerves and blood vessels pass.

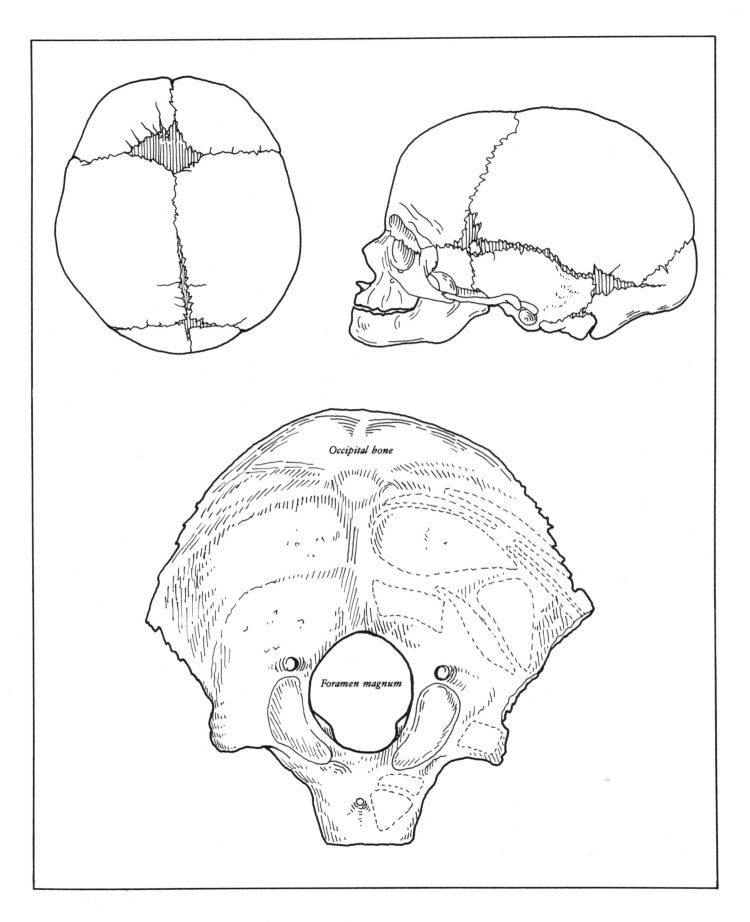

Top: Two views of the skull at birth; the bones have not yet completely fused together. *Bottom:* The occipital bone, seen from the outside as if separated from the rest of the skull. The prominent ridges are where the muscles which hold the head up straight are attached.

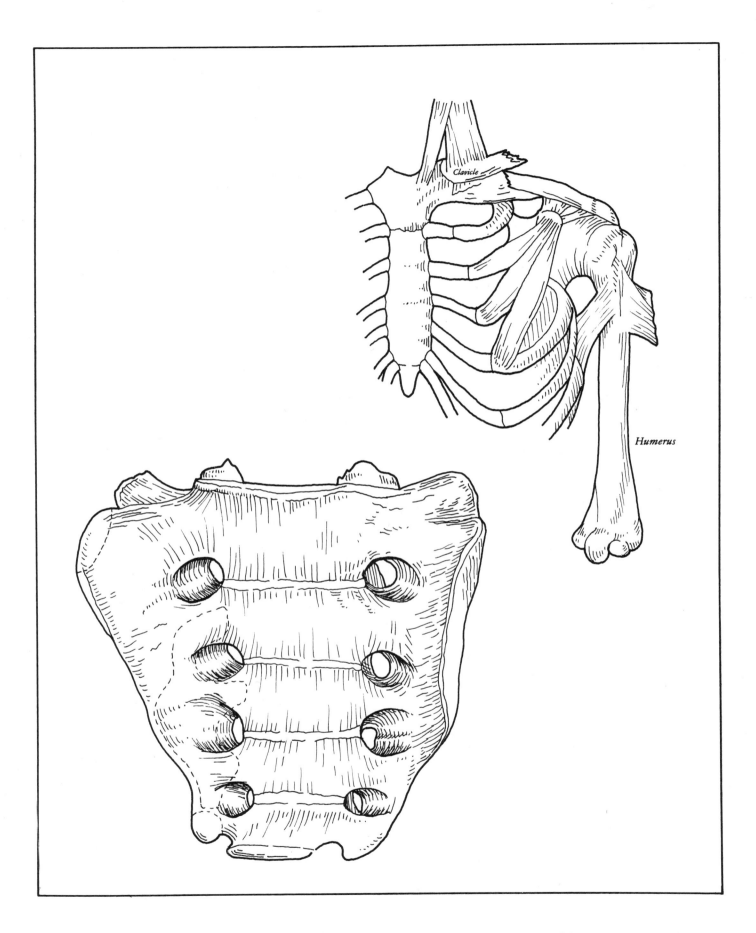

Top: The bones of the shoulder girdle. Note the fracture in the left clavicle, one of the supporting bones of the shoulder. *Bottom:* The sacrum. This is one of the lowermost parts of the backbone, or vertebral column. The prominent holes are where the spinal nerve leaves its canal at each level.

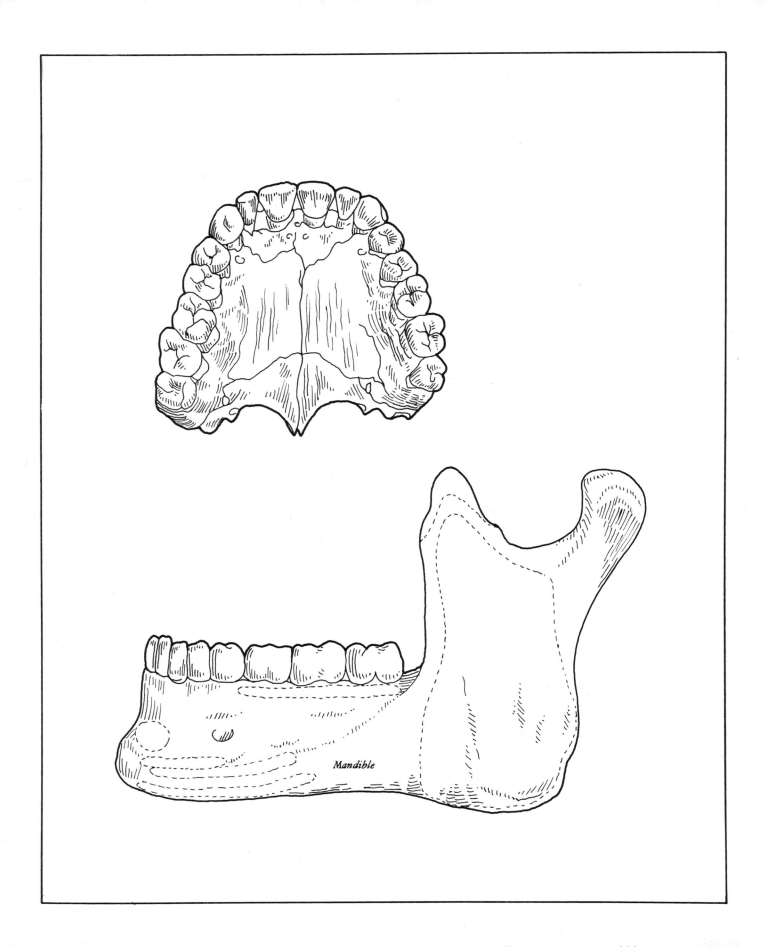

Top: The hard palate, with the teeth in place, seen from below. *Bottom:* The jaw bone, or mandible. The large vertical area on the right is for the attachment of the masseter muscle, the largest of the muscles used in chewing.

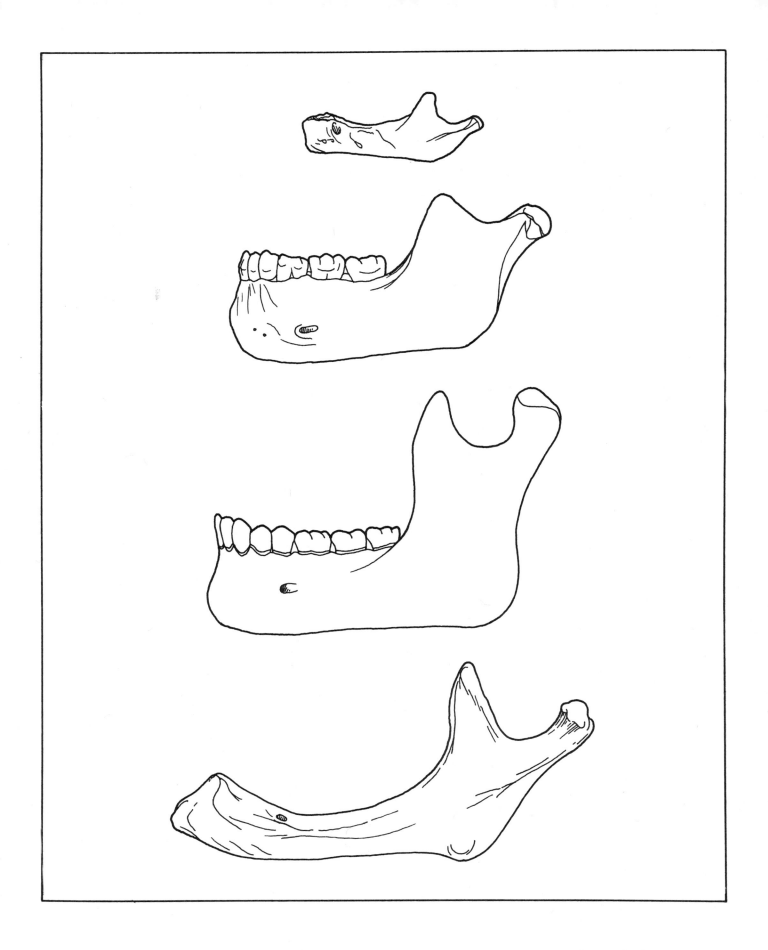

A side view of the lower jaw at different periods of life. From top to bottom, the jaw is shown at birth, at puberty, in the adult, and in old age.

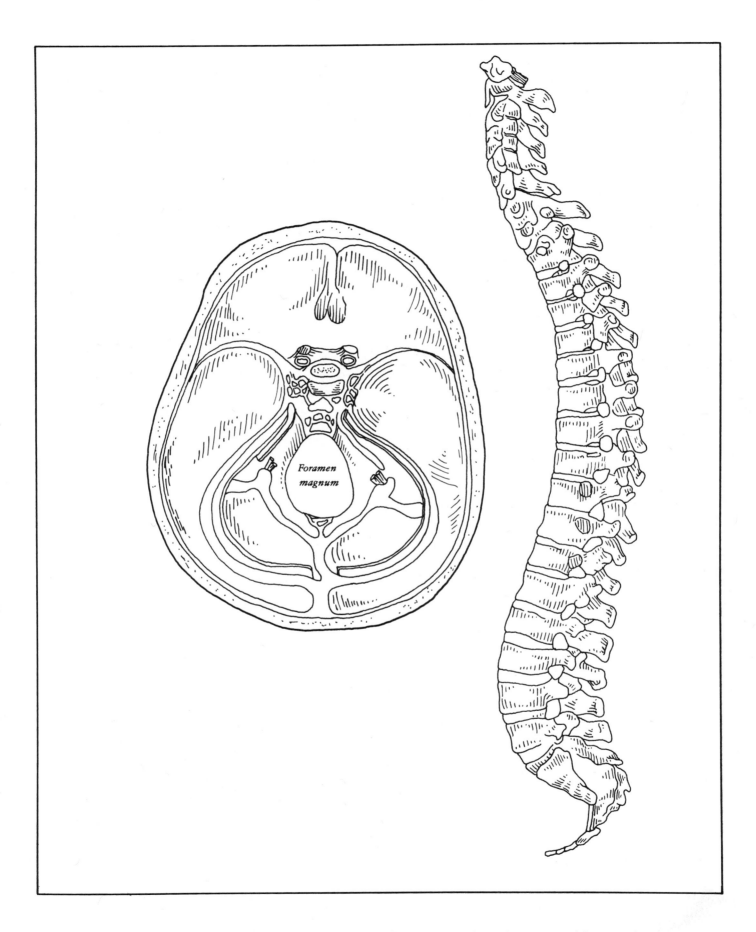

Foramen
magnum

Left: The base of the skull as seen from the inside. The large vessels inside are some of the veins that drain blood from the brain. The foramen magnum is for passage of the spinal cord. *Right:* The entire spine, or vertebral column, seen from the side. Notice the curvature that is normally present.

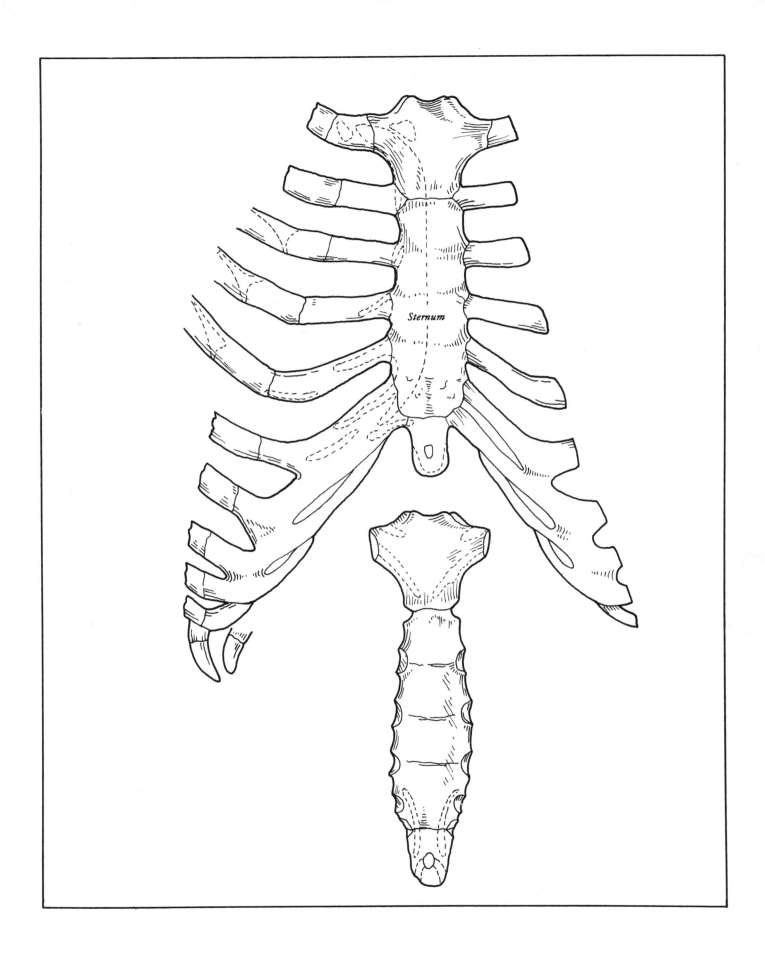

Top: This shows the attachment of the ribs to the breastplate, or sternum. *Below:* The sternum with the ribs separated from it as seen from behind.

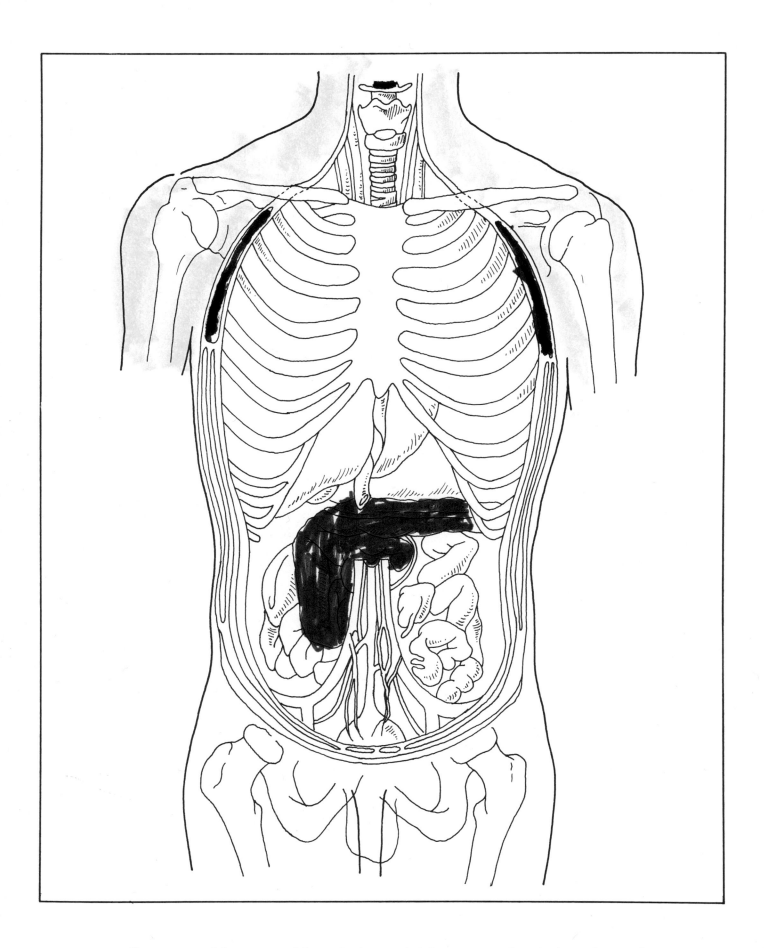

This is a view of the contents of the neck, chest, and abdomen as seen from the front, showing the vital organs they contain. Bones of the shoulder girdle, rib cage, and pelvis are also shown.

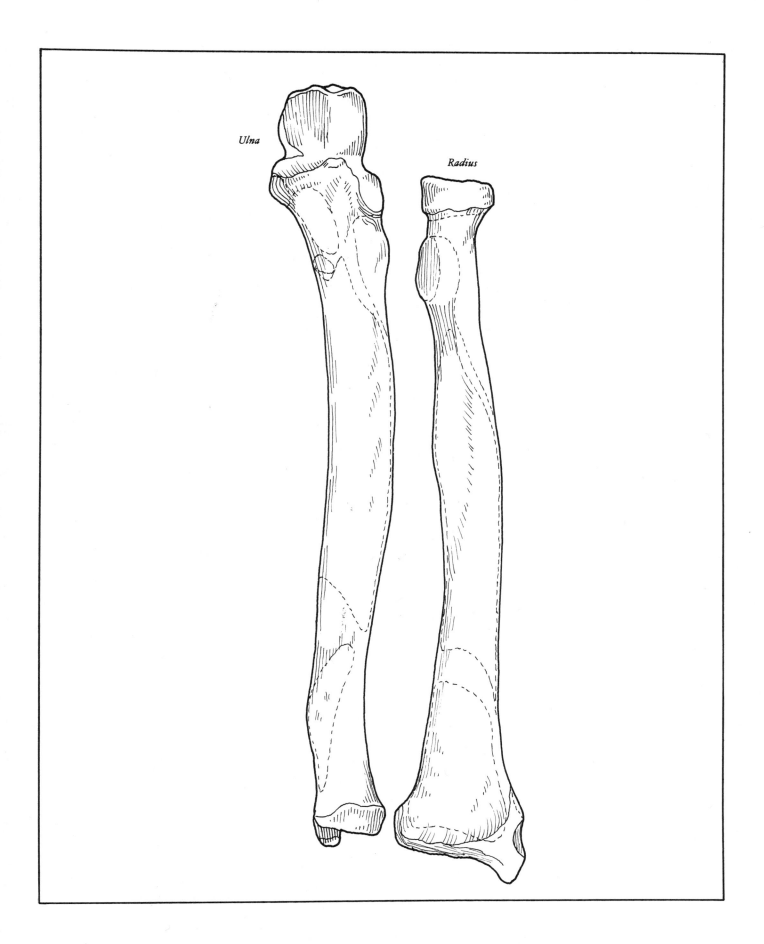

Ulna

Radius

Bones of the left forearm. The two bones of the forearm are shown from the front. On the thumb side is the radius, and on the inside (as seen with the palm facing up) is the ulna. The prominent ridges are for the attachments of the muscles which move the bones.

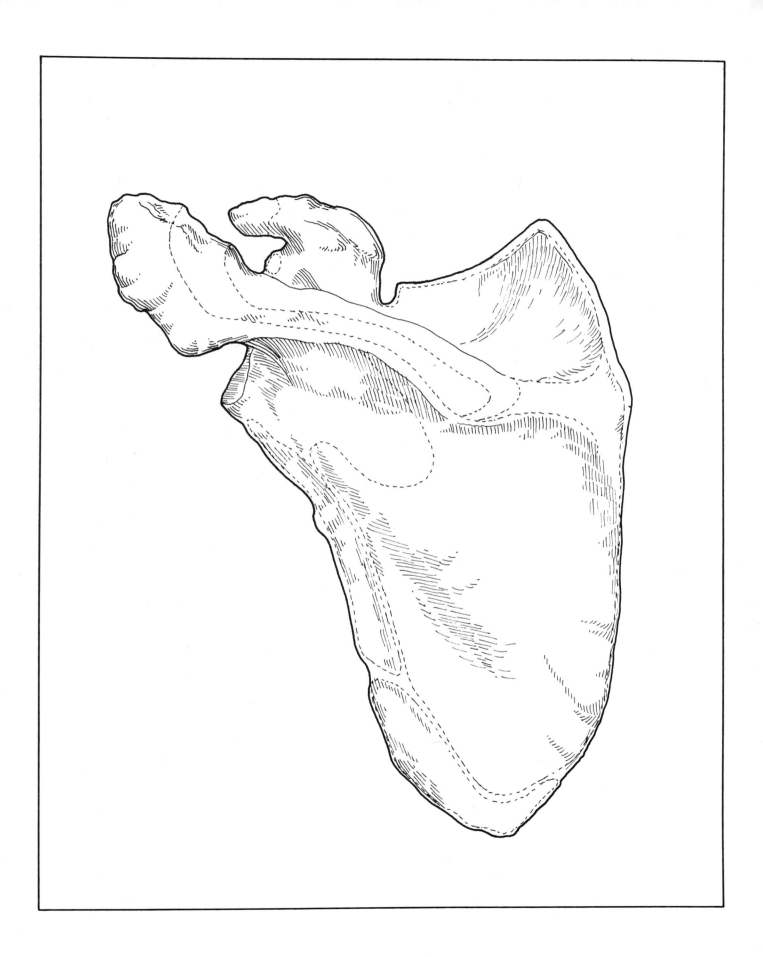

This is the left shoulder blade, or scapula, as seen from behind. It is one of the major bones of the shoulder girdle, situated against the ribs on the back part of the chest.

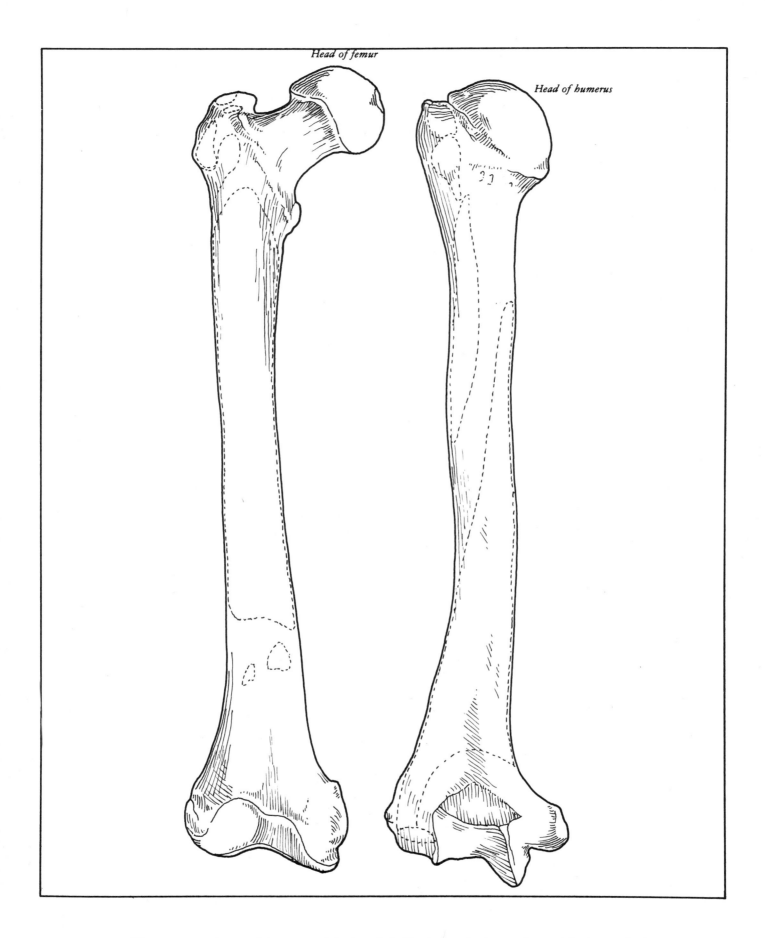

Head of femur

Head of humerus

The uppermost bones of the arm and the leg. *Left:* The femur, the largest bone in the human body. *Right:* The humerus, the largest of the arm bones. Notice the similarity in basic shape of the femur and the humerus.

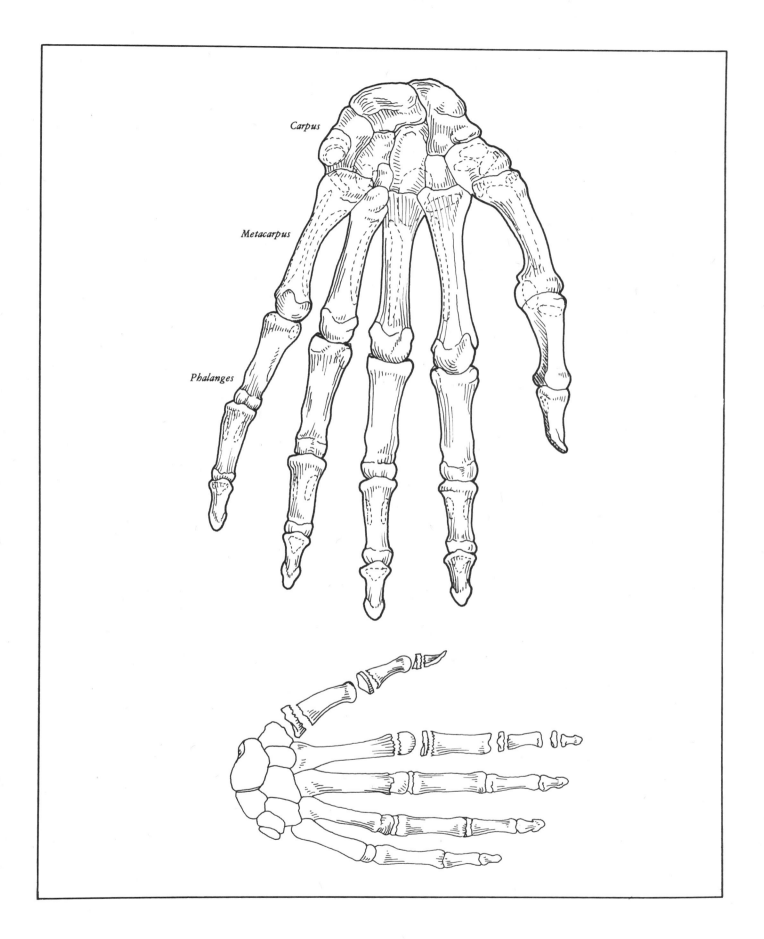

Carpus

Metacarpus

Phalanges

Bones of the hand. The eight bones of the wrist taken as a group are called the carpals. In the palm the bones are the metacarpals. The bones of the fingers and the thumbs are the phalanges—three in each finger and two in the thumbs.

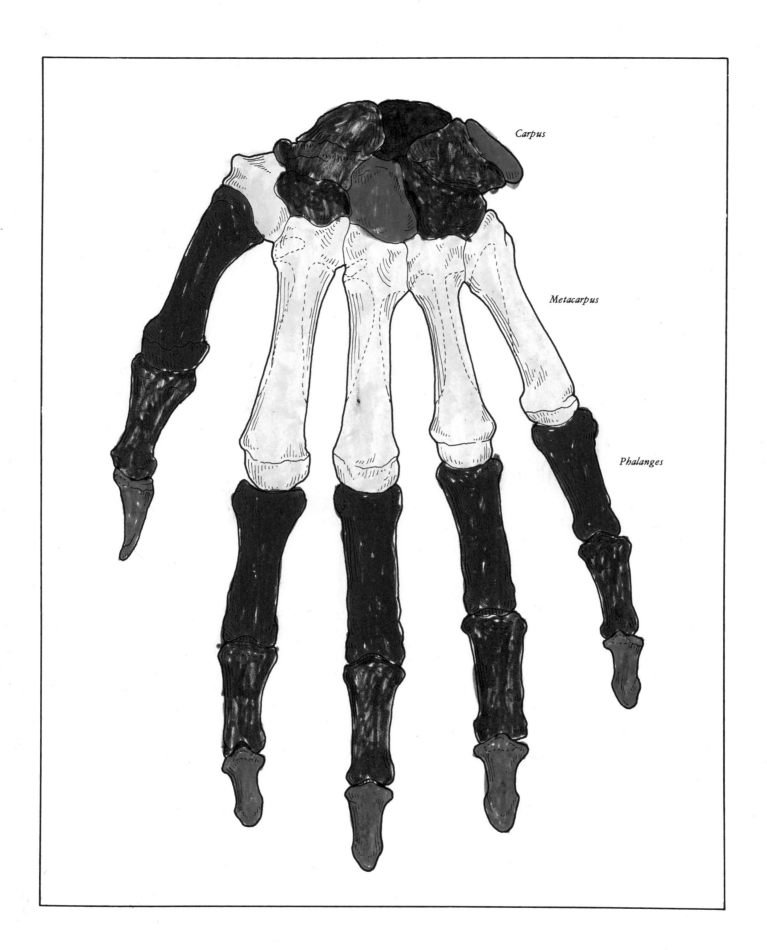

Carpus

Metacarpus

Phalanges

The bones of the left hand, seen with the palm facing down.

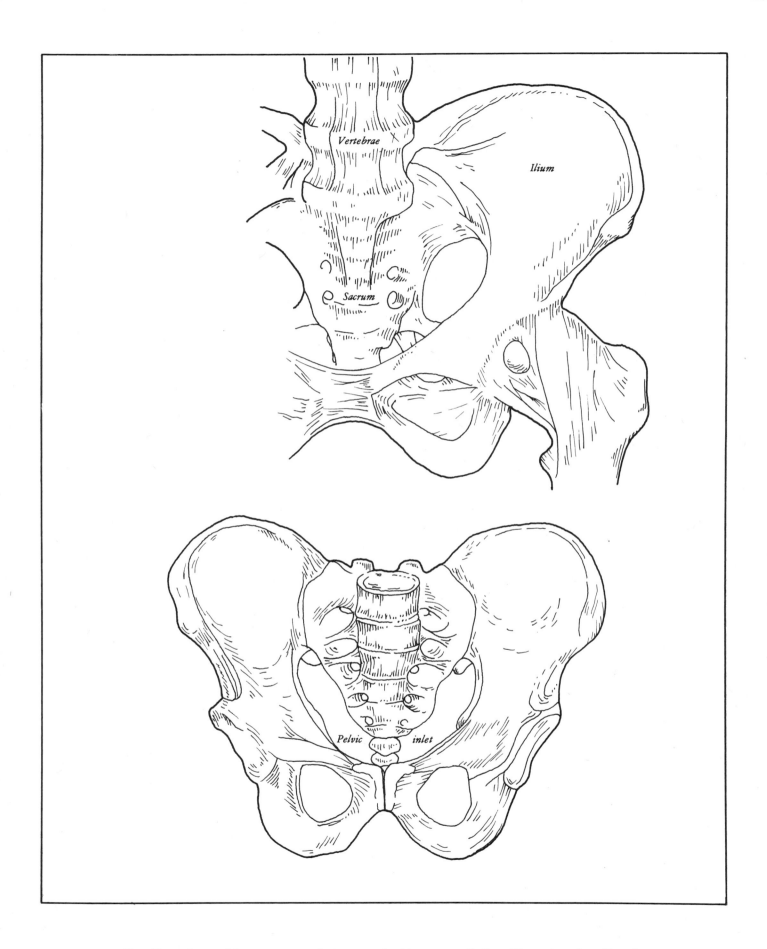

Top: The pelvis and hip are seen with their attached ligaments. *Bottom:* The male pelvis. Note the shape of the large hole, the pelvic inlet, in front of the sacrum.

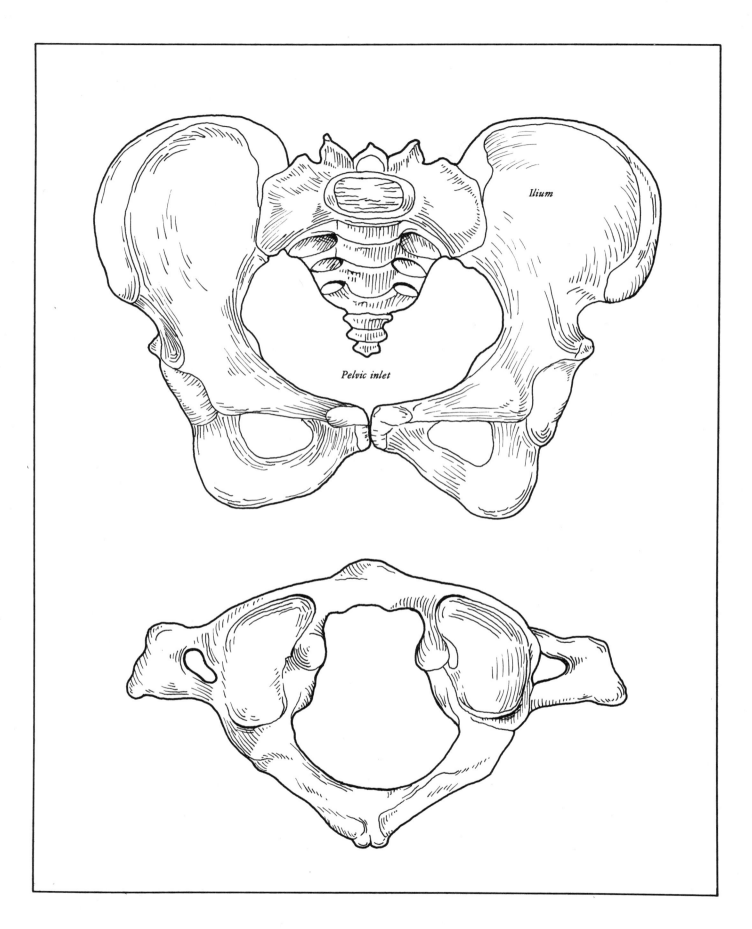

Top: The female pelvis. Note the shape of the female pelvic inlet, enlarged for childbearing.
Bottom: This is the first cervical vertebra, called the atlas, which supports the skull yet allows for rotation of the head.

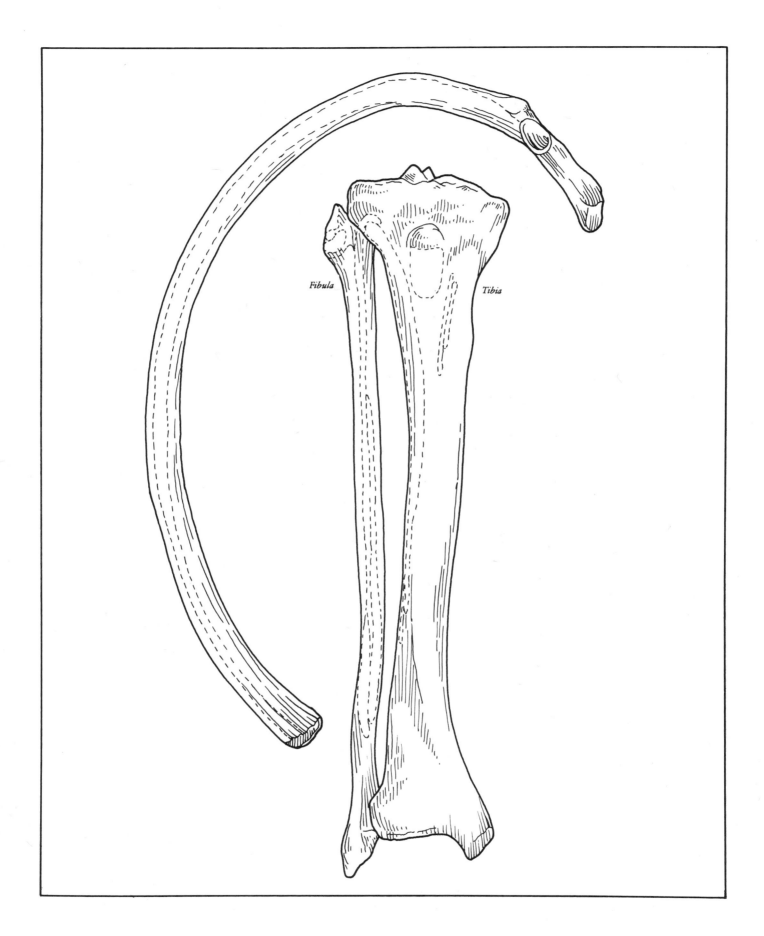

Left: A central rib of the left side of the body. *Right:* Seen from the front, the bones of the right leg between the knee and the ankle. The tibia (or shin bone) is the larger of this pair; the smaller one is called the fibula.

Bones of the foot. The basic layout is similar to that of the hand. The bones of the ankle are the tarsals; then come the metatarsals with the attached phalanges.

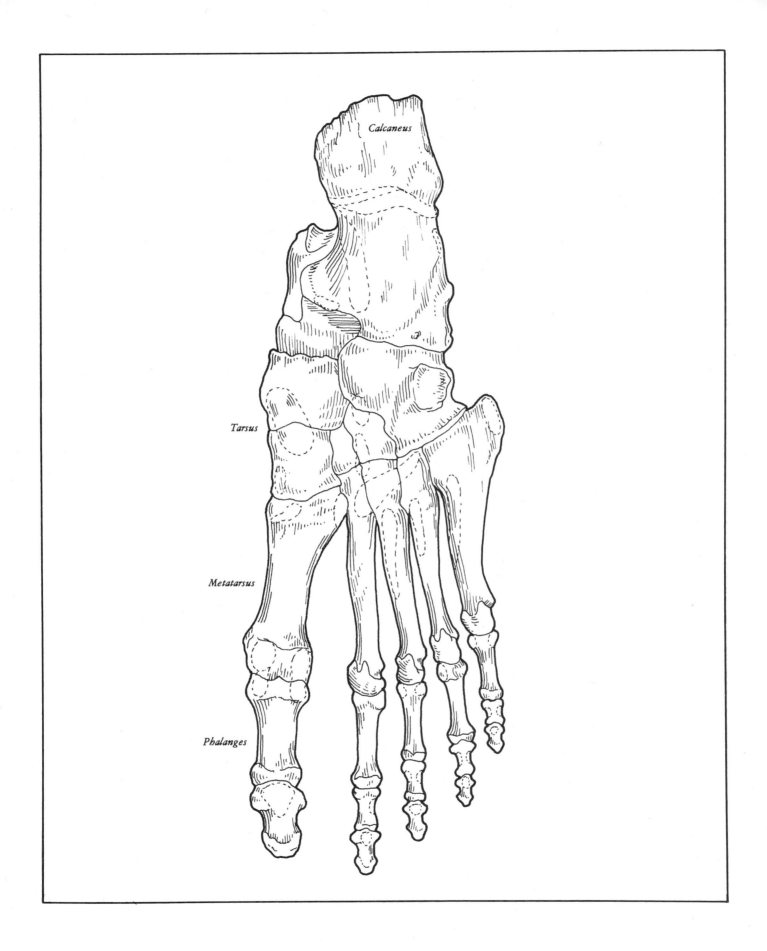

The bones of the right foot, seen from the bottom surface of the foot.

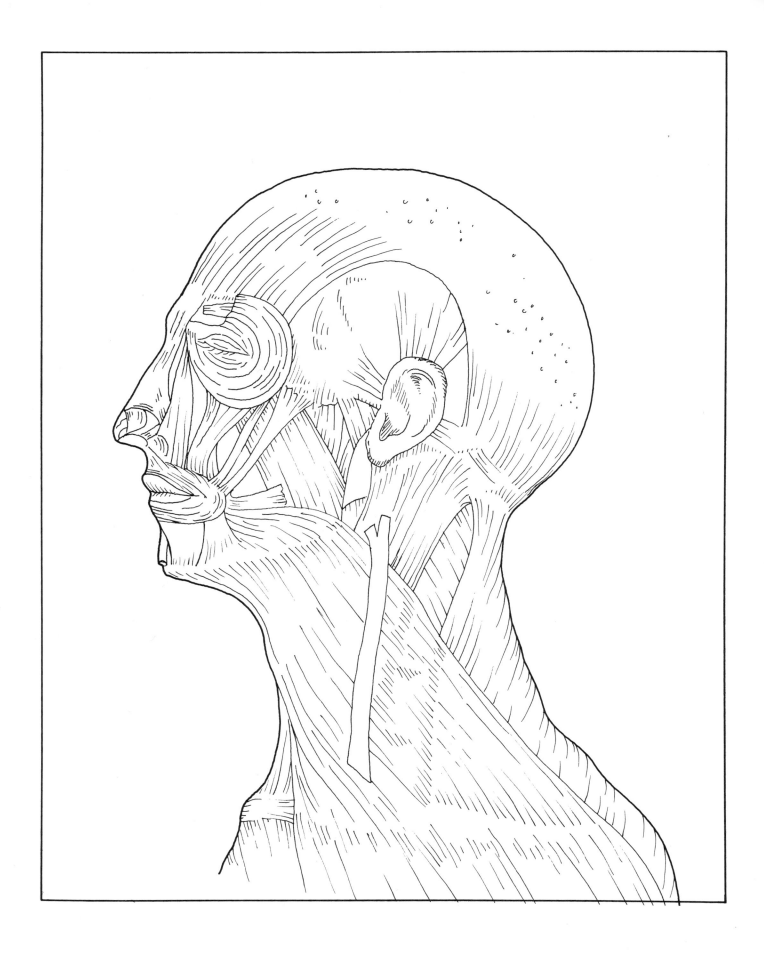

Muscles of the head, face, and neck. The surface muscles of the face are known as the muscles of facial expression.

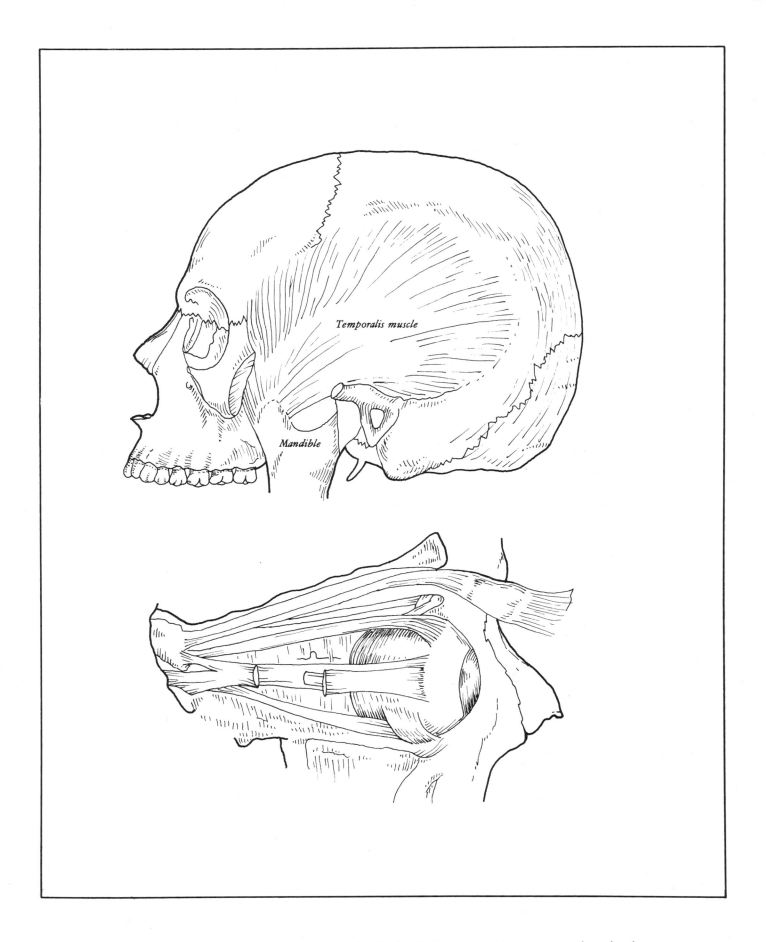

Top: This view shows the left temporalis muscle attached to the temporal bone on one side and to the lower jaw, or mandible, on the other. It is one of the muscles that we use in chewing. *Bottom:* The eyeball in place in the eye socket, showing the muscles used in moving the eye.

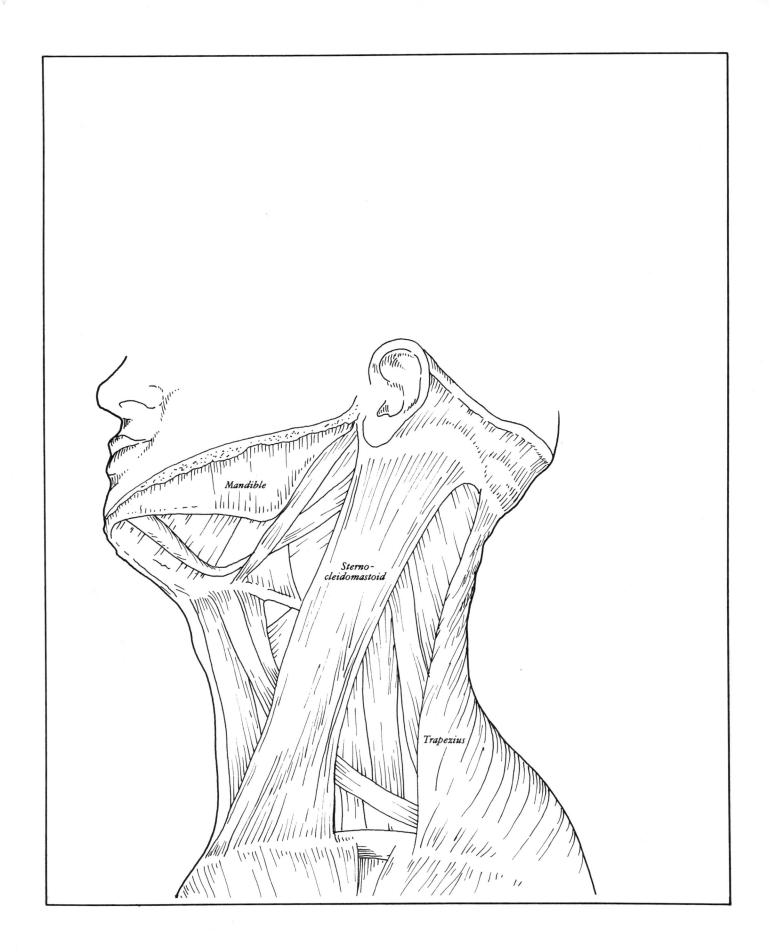

Muscles of the neck. This view of the left side of the neck shows many of the muscles used in normal swallowing and holding the head upright.

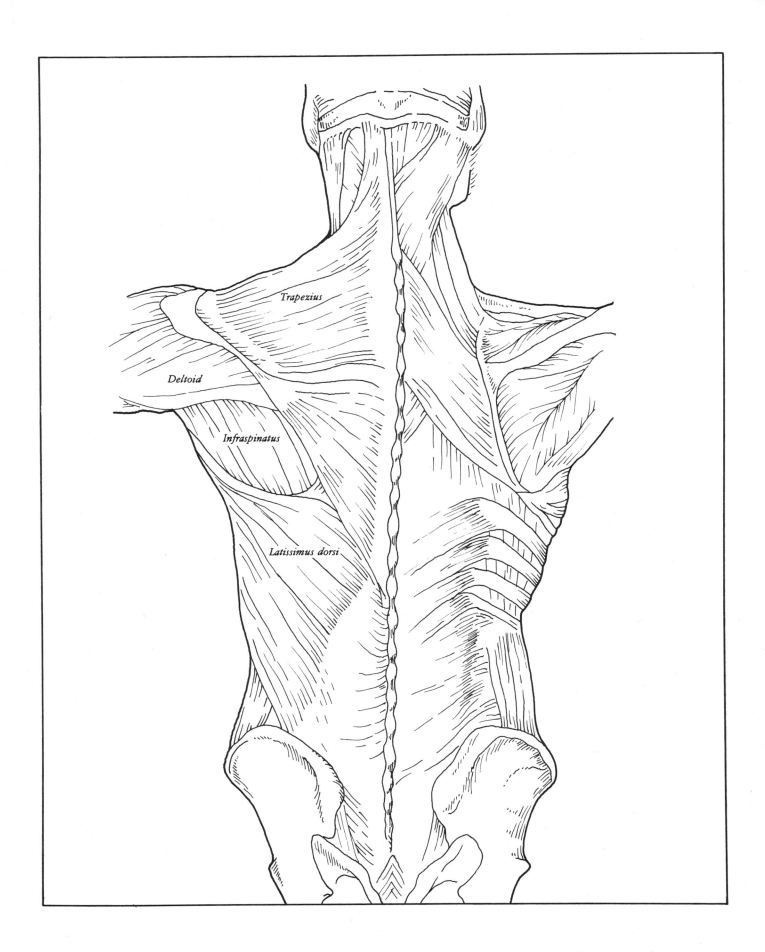

Muscles of the back. On the left, the first layer of muscles is seen. Some of these have been removed on the right side to show deeper layers of the back muscles.

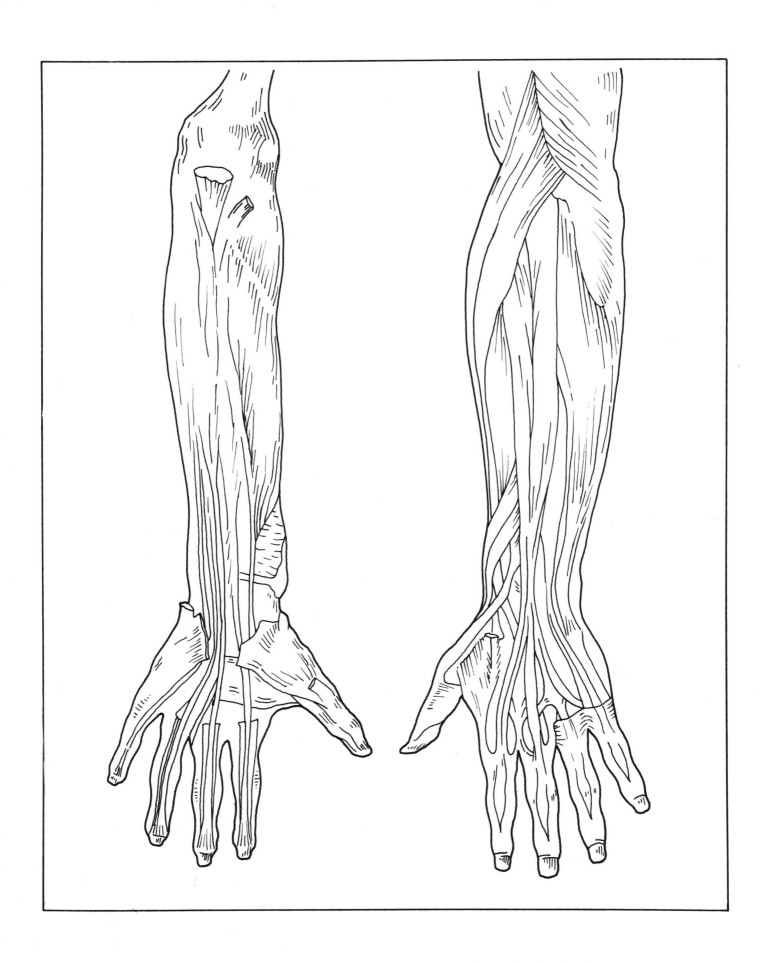

These two drawings show the muscles and tendons of both the front and back of the forearm and hand. In the view of the front *(left)* we see the deep muscles; in the back *(right),* the surface muscles.

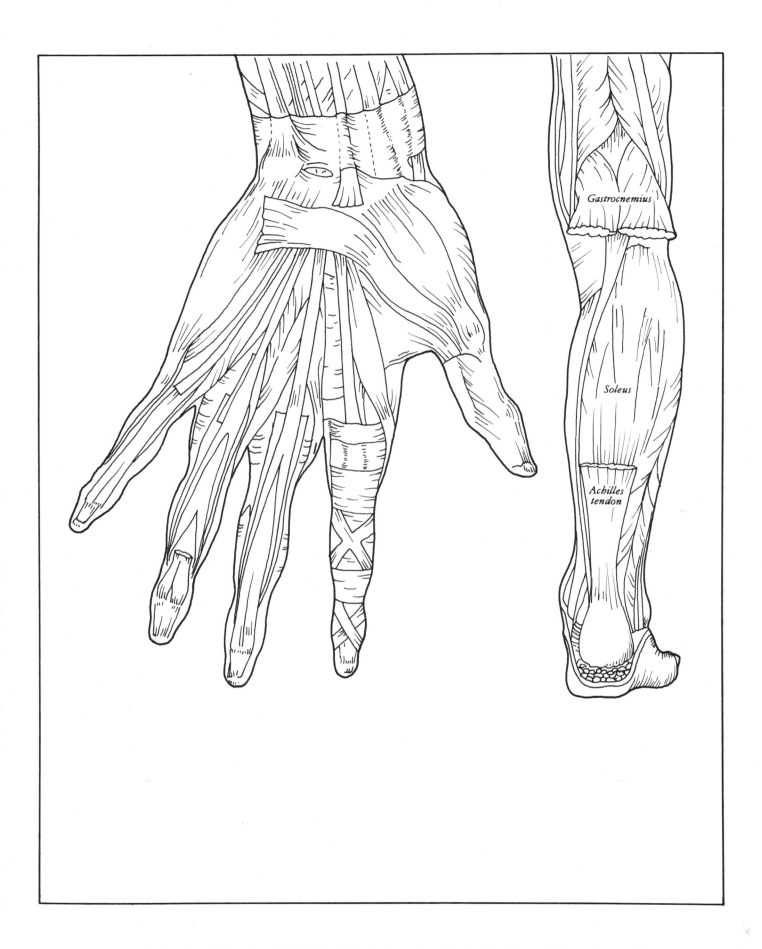

Left: Muscles of the palm of the left hand. *Right:* Muscles of the back of the right leg with part of the largest muscle, the gastrocnemius, removed.

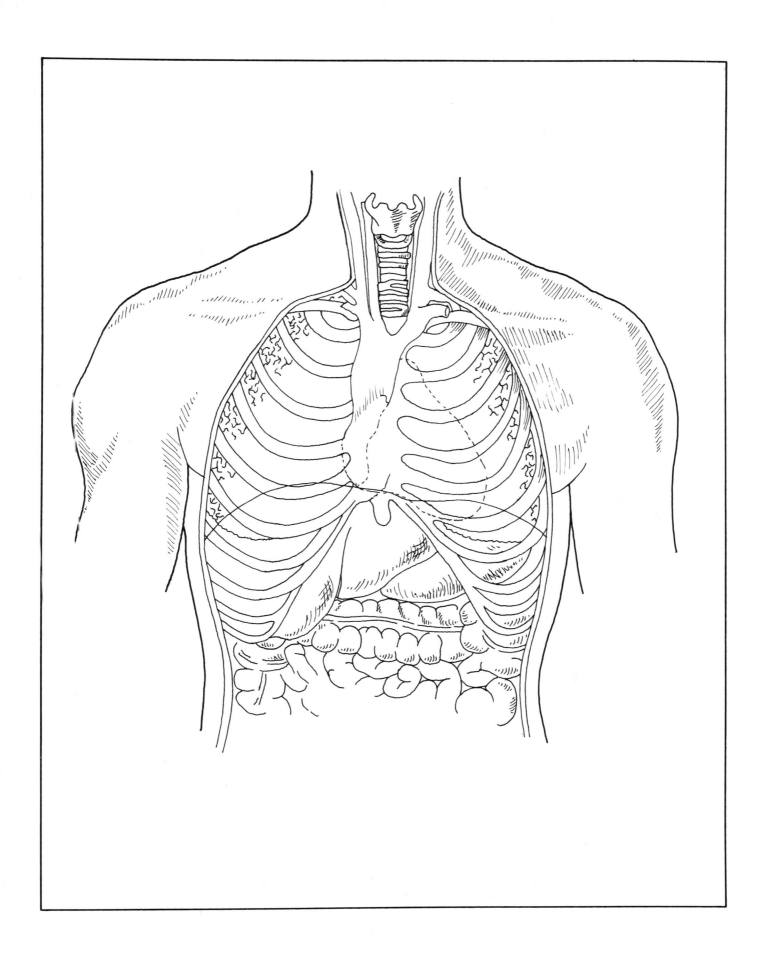

A view of the front of the chest, or thorax, showing the positions of its major organs.

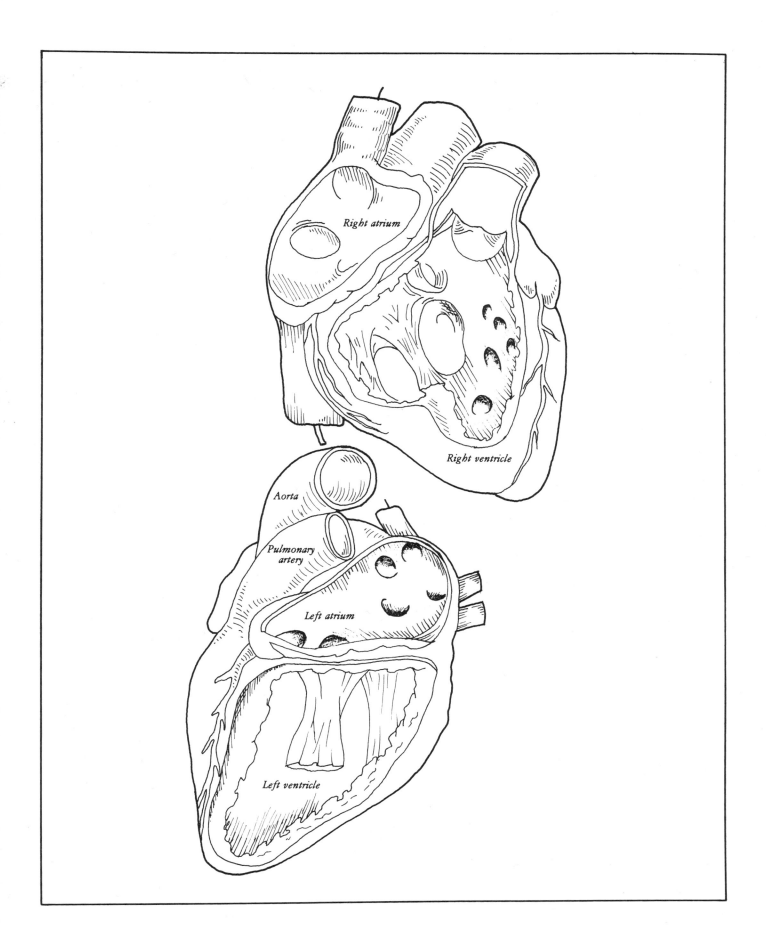

The heart, showing its chambers and valves, and the large blood vessels leading to and from the heart. *Top:* The left-side chambers as seen from behind. *Bottom:* A front view showing the smaller, right-side chambers.

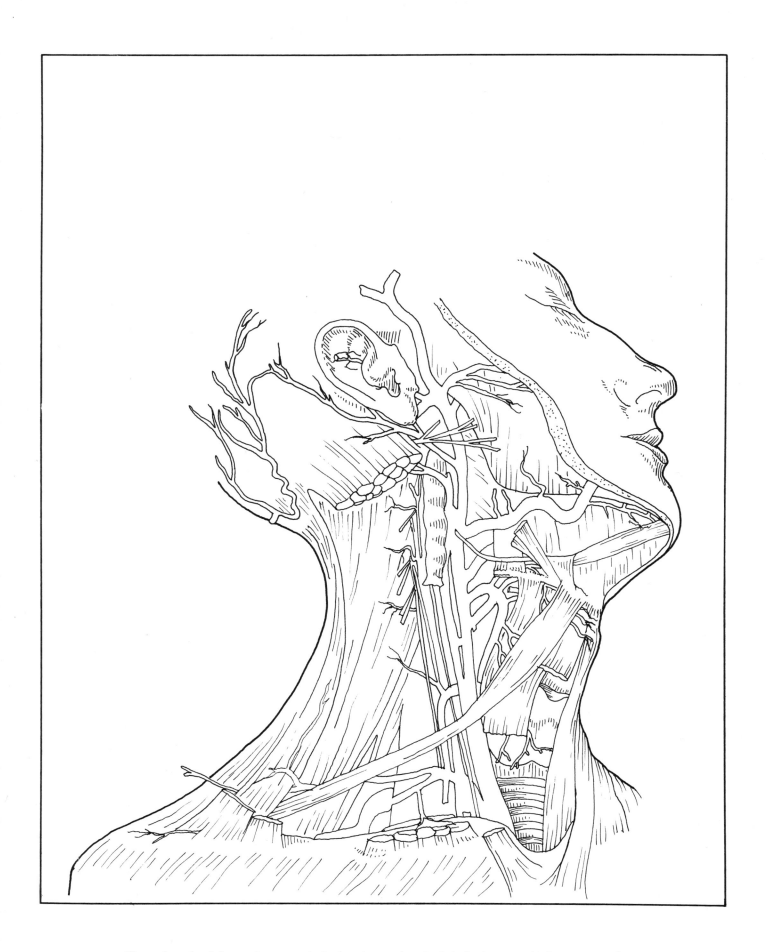

The right side of the neck seen with the head turned to the left. In this view (with some muscles removed) we see the main arteries that supply the head and neck with blood.

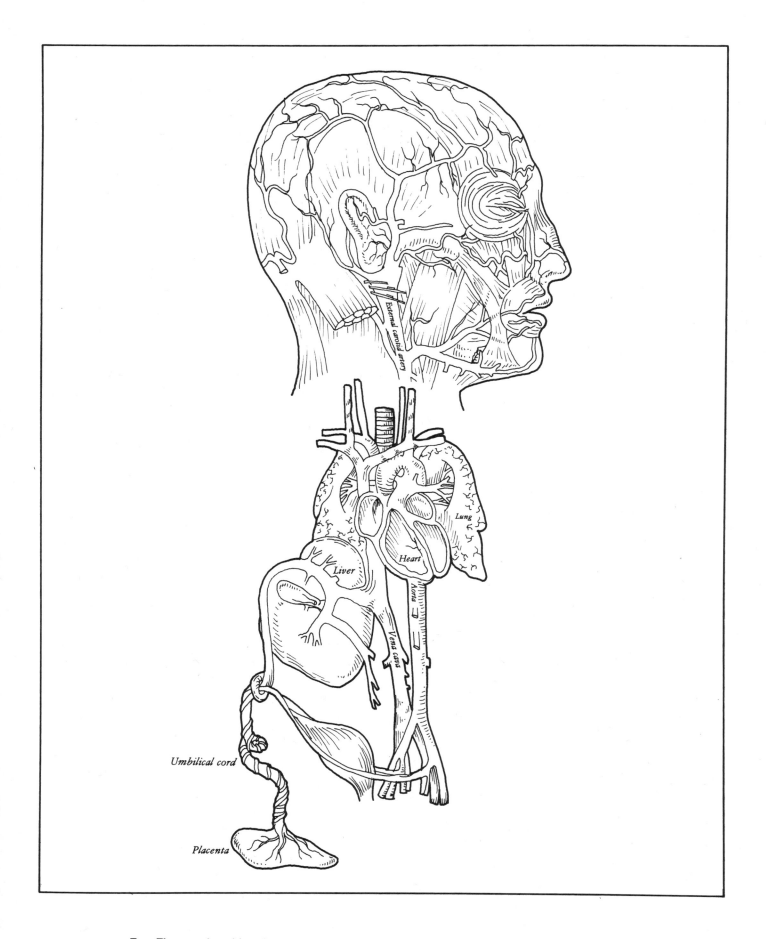

Top: The muscles of facial expression and some of the arteries that supply blood to the structures of the face. *Bottom:* This drawing shows the circulation of the blood to the fetus, or unborn child.

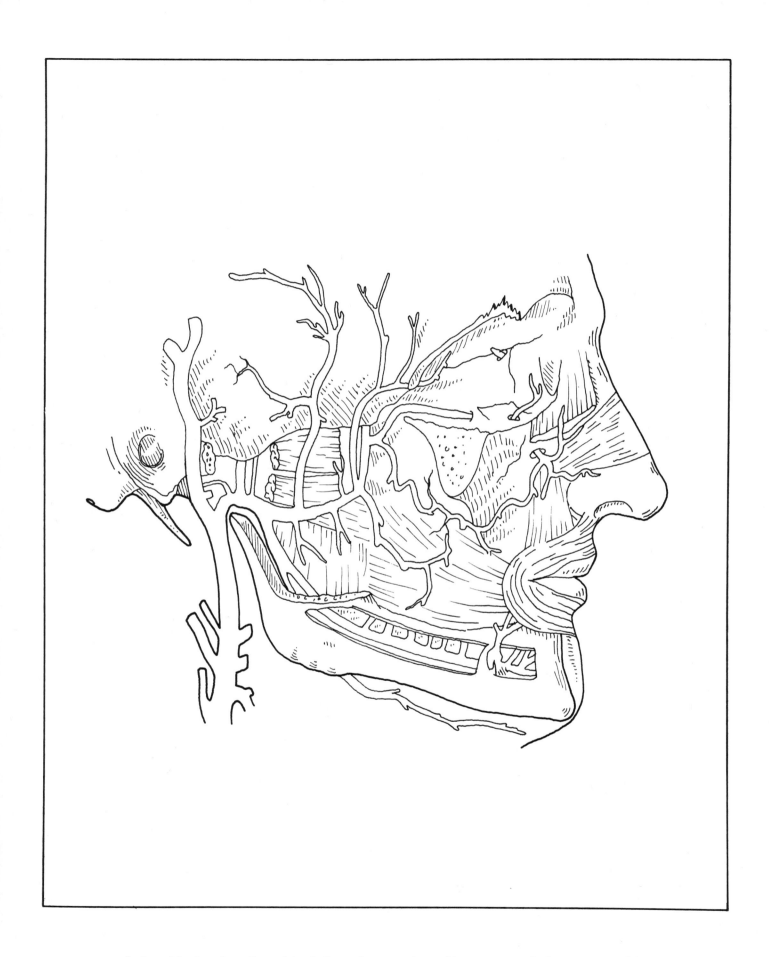

A view of the face from the right with the surface muscles and bones removed, showing some of the deeper structures and their blood supply.

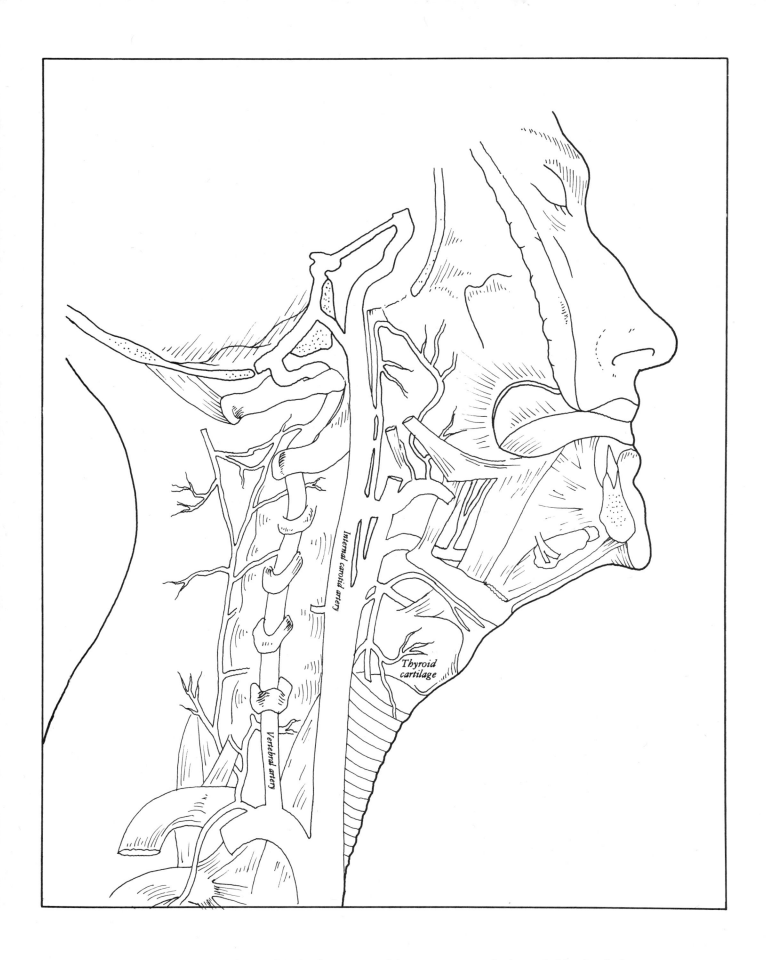

Internal carotid artery

Vertebral artery

Thyroid cartilage

The right side of the face and neck, showing two of the main arteries which supply blood to the brain
—the right internal carotid and vertebral arteries. Note the thyroid cartilage, or "Adam's Apple."

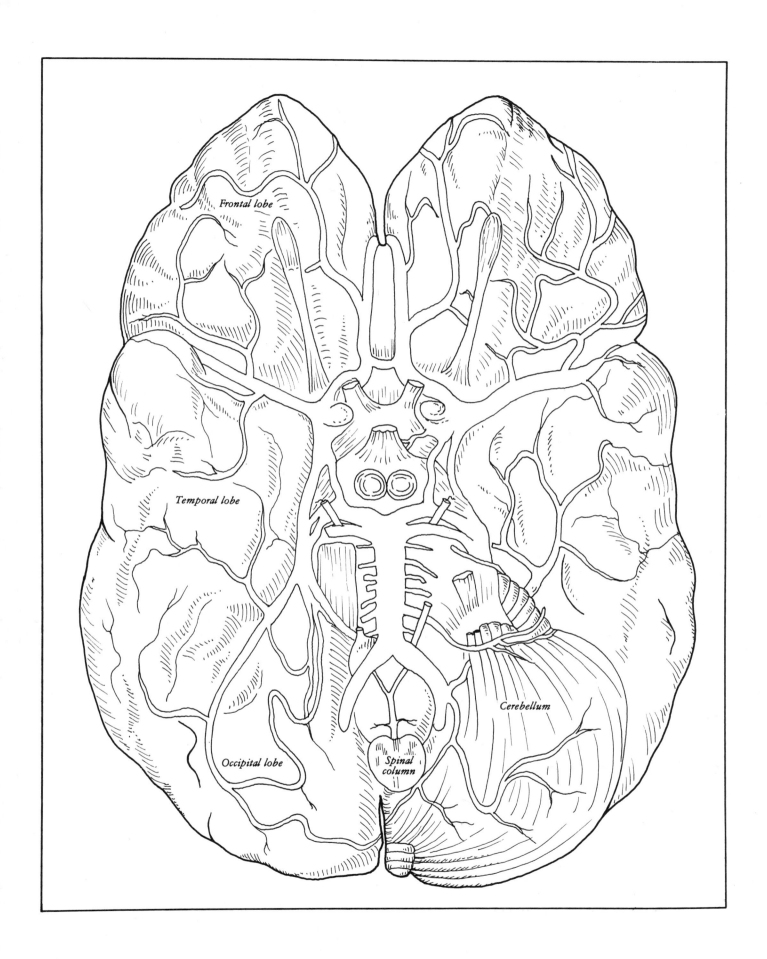

The brain as seen from its bottom surface, showing the arteries that supply it. On the left side the cerebellum has been removed to show the occipital lobe of the brain.

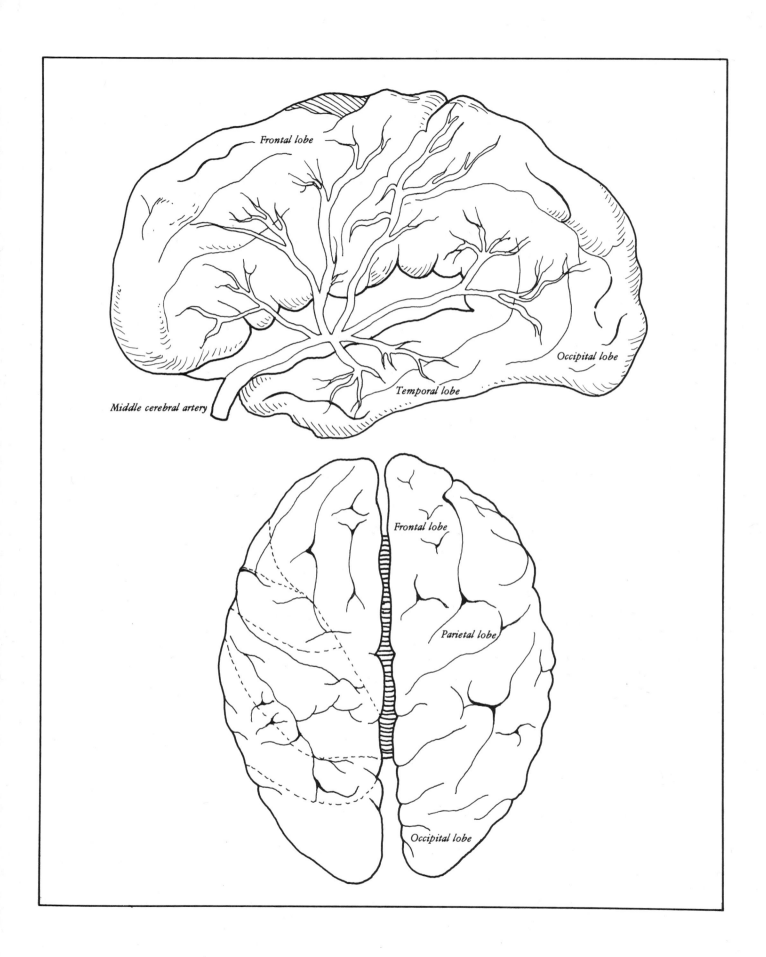

Top: The left side of the brain and the arteries that supply part of its surface. *Bottom:* The outer surface of the brain as seen from the top.

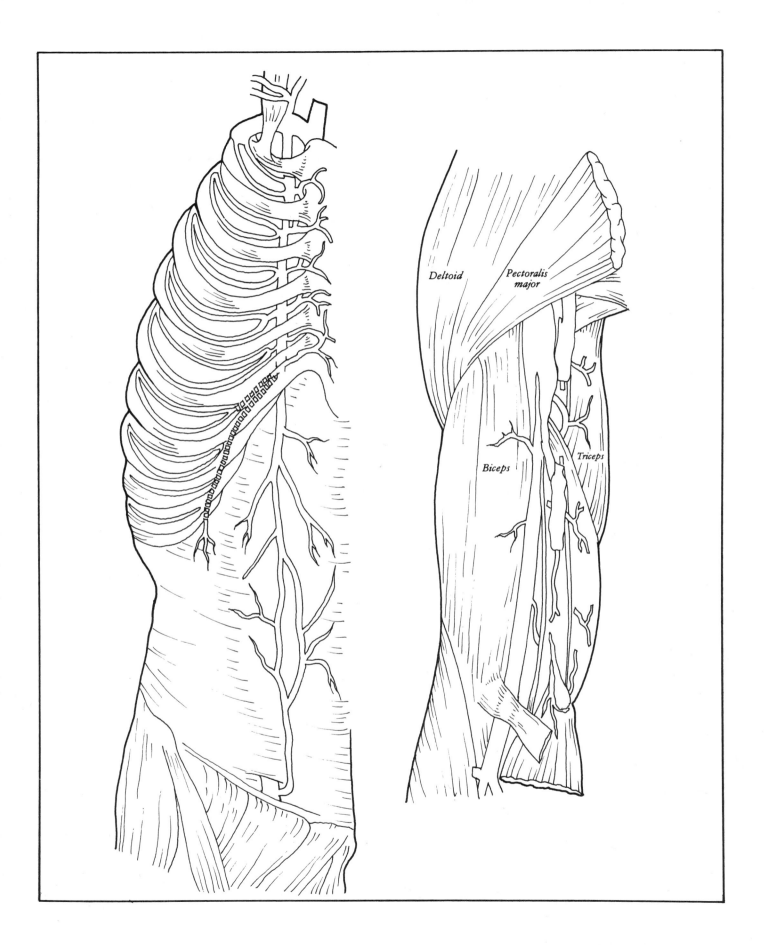

Left: The left chest wall as seen from the inside, showing the ribs and some of the arteries that supply the region. *Right:* The major muscles of the upper arm are shown with the major arteries that supply the entire arm.

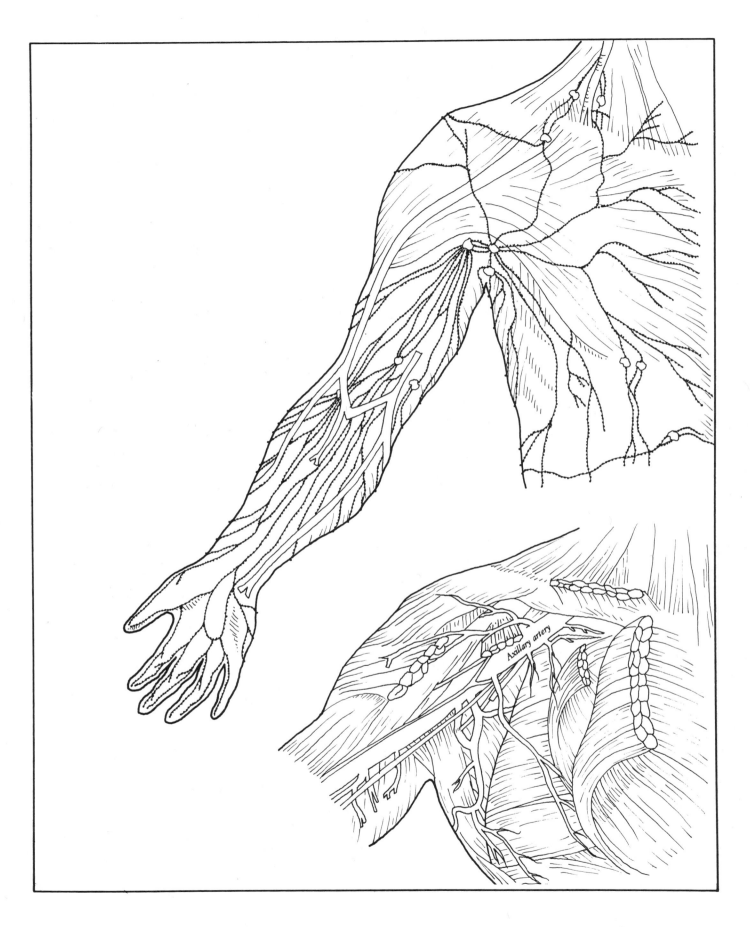

Top: The lymphatic vessels of the chest and arm. The lymph system is for drainage of tissue fluids. *Bottom:* The axillary artery and its branches. This is the major artery supplying blood to the side of the chest wall and upper arm.

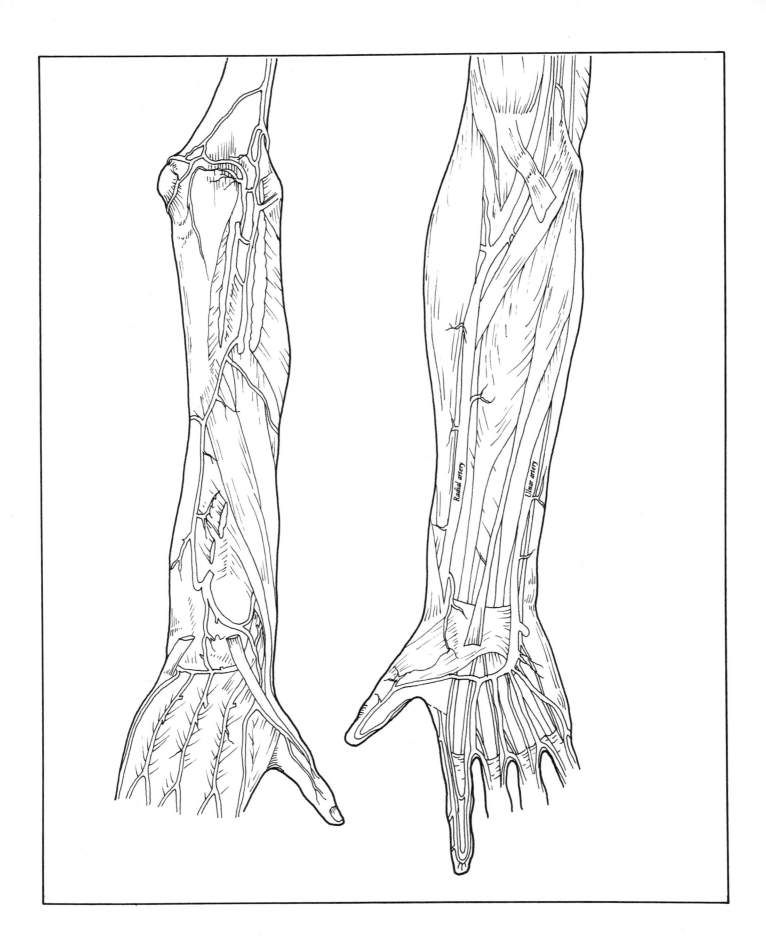

The individual arteries that supply the front and back of the arm are shown. The radial artery is the one from which the pulse rate at the wrist is counted; the other major artery of the arm is the ulnar.

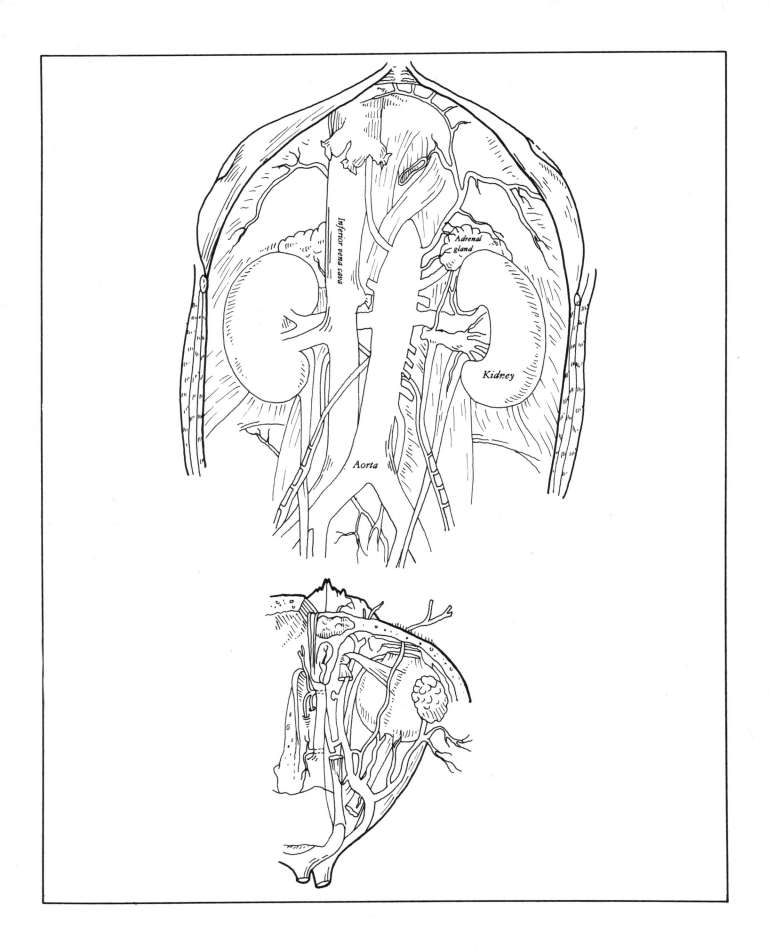

Top: A view looking into the abdomen from the front, with the liver and intestines removed. The body's largest blood vessel, the aorta, and some of its main branches are shown. *Bottom:* The major blood vessels of the eye, seen as if all the surrounding bones and tissues had been removed.

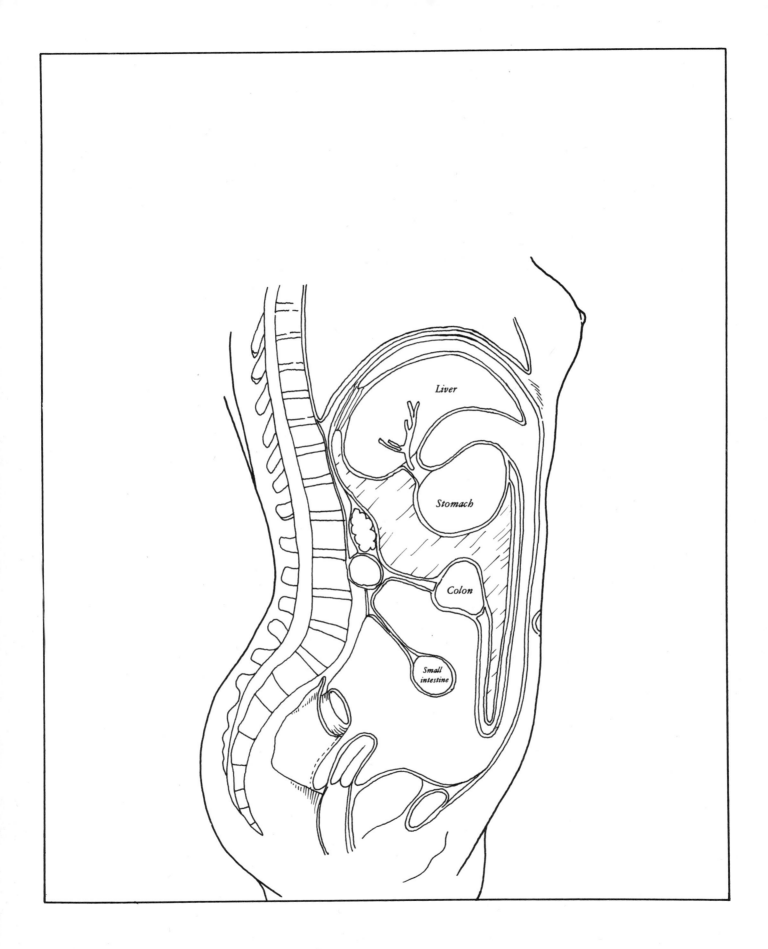

A side view of the major organs of digestion, shown in relation to the chest cavity, backbone, and reproductive organs in the female.

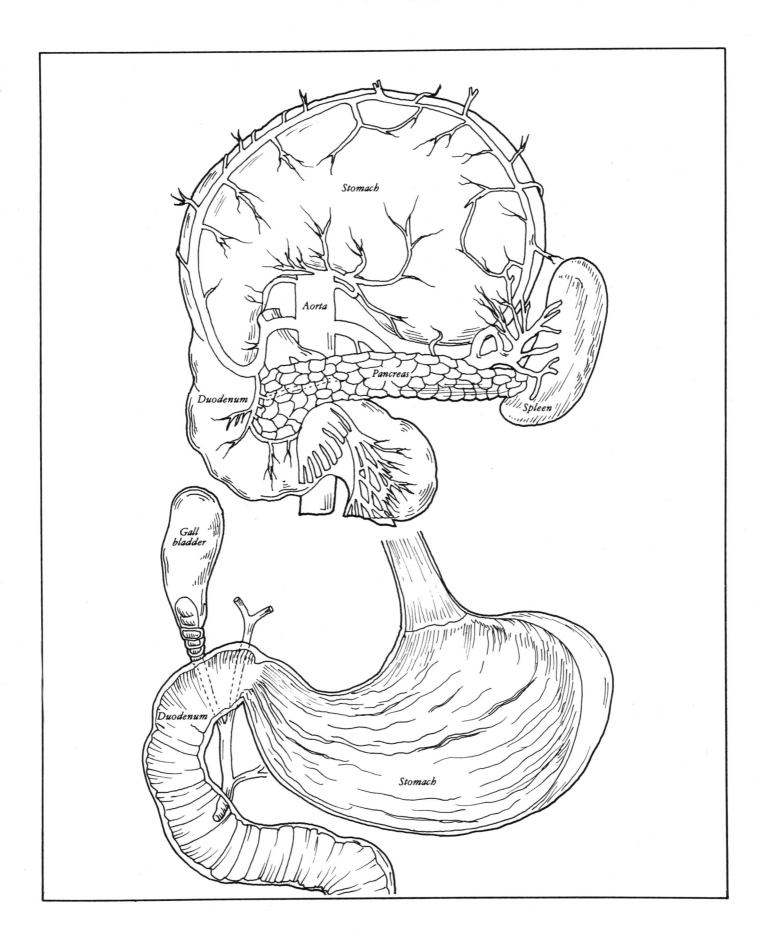

Top: The stomach has been flopped up to show the other digestive organs behind it and the major arteries which supply the region. *Bottom:* A cut-away view of the stomach in its normal position.

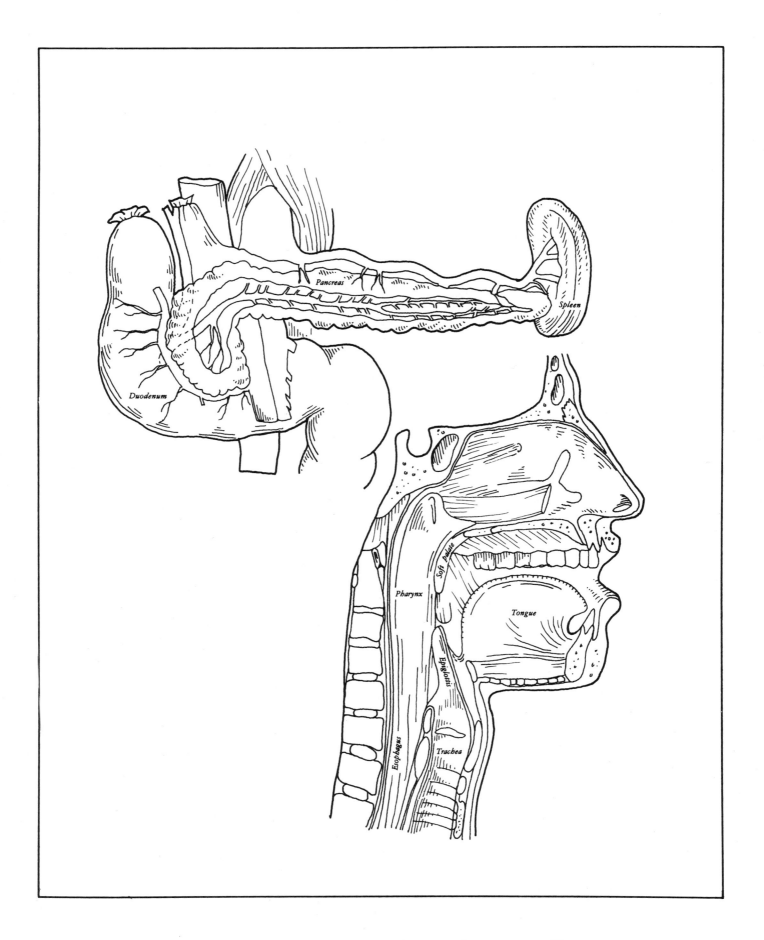

Left: The pancreas is shown in relation to some of the other digestive organs. The pancreas secretes digestive juices and the hormone insulin. *Right:* A side view of the nose, mouth, and throat. Note the sections of backbone, or cervical vertebrae, shown on the left side of this drawing.

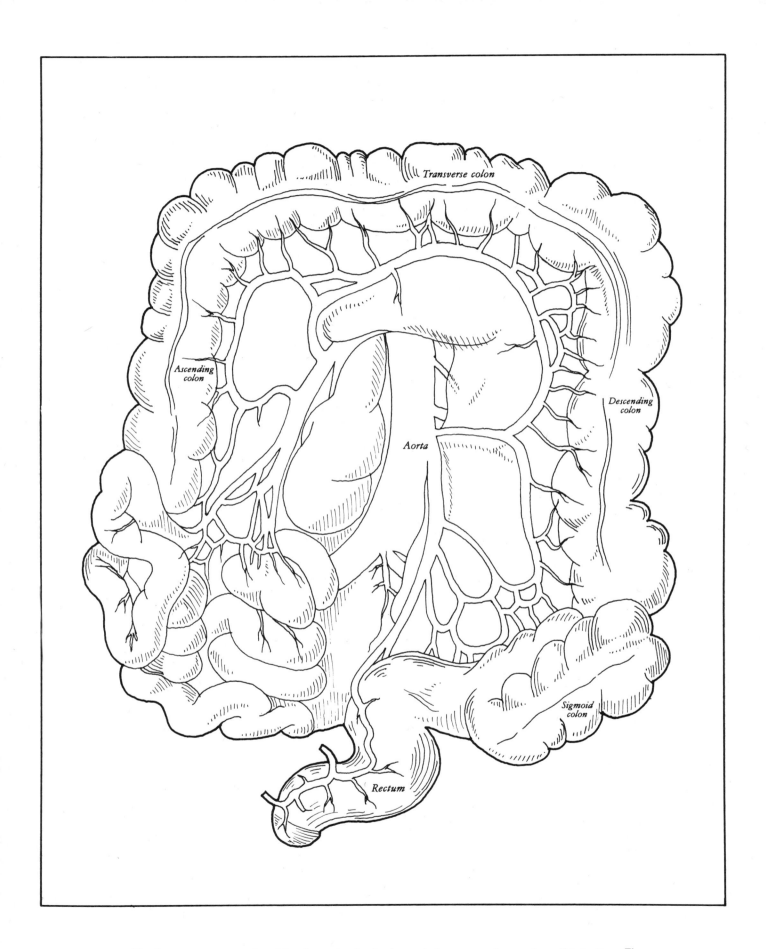

The large intestine and its blood supply. In the lower left area are loops of small intestine. These lead up into the large intestine, which circles around the abdomen and ends with the rectum.

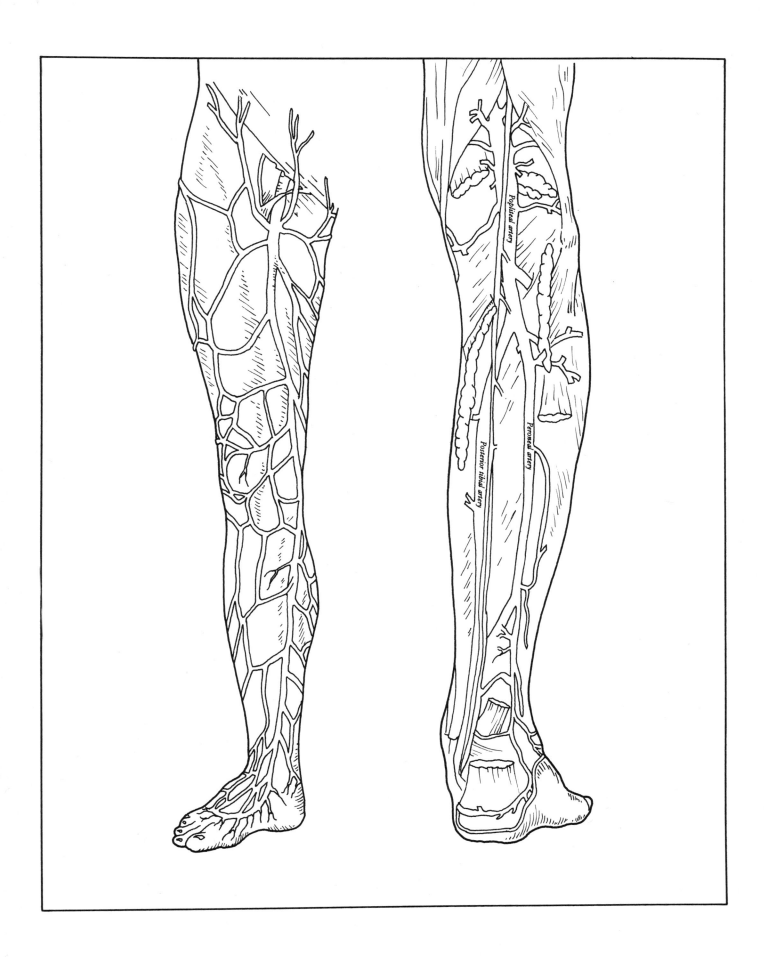

Left: The surface veins of the front of the entire leg. *Right:* The major arteries to the back of the leg.

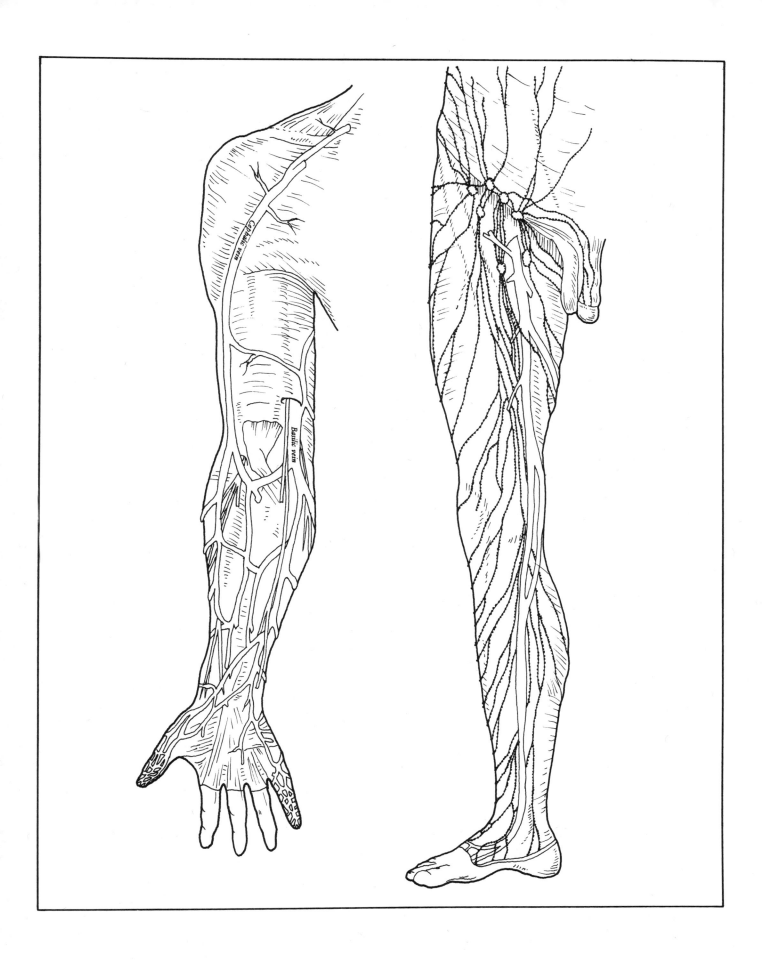

Left: The surface veins on the front of the right arm. *Right:* The lymph vessels and lymph nodes of the leg and groin.

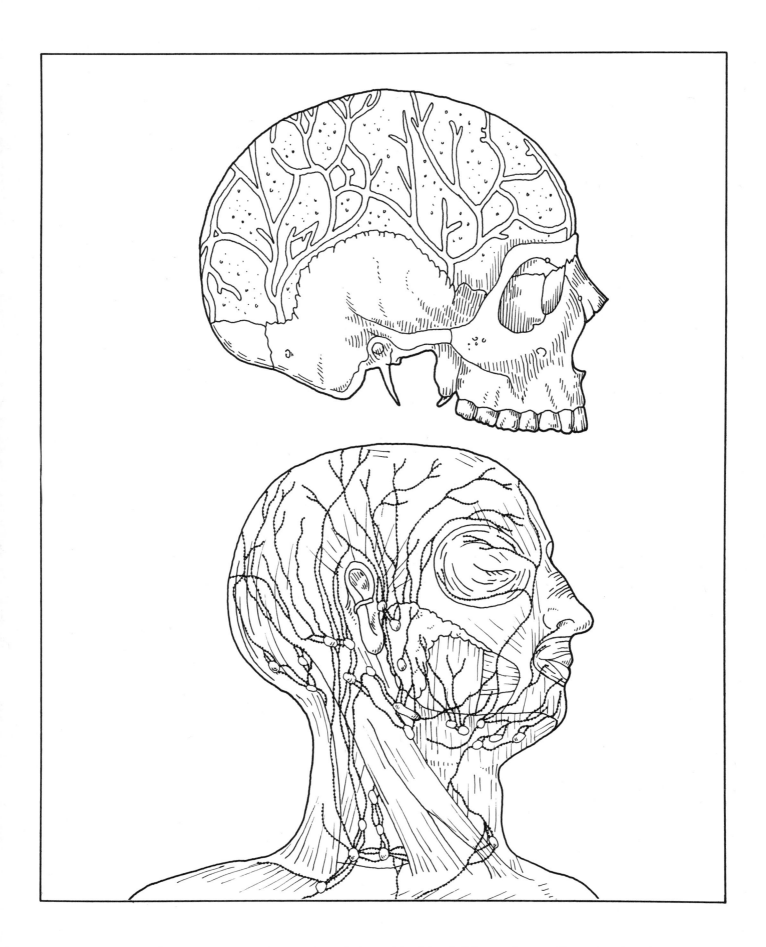

Top: These are the veins that run through the inside of the skull bones. *Bottom:* The surface lymph vessels and nodes (or "glands") of the head and neck.

The surface veins of the head and neck are shown in relation to the first layer of muscles.

The portal vein and its branches from the digestive organs. The portal system of veins drains the blood from the intestines. The liver's front surface has been pulled up to show what is beneath it.

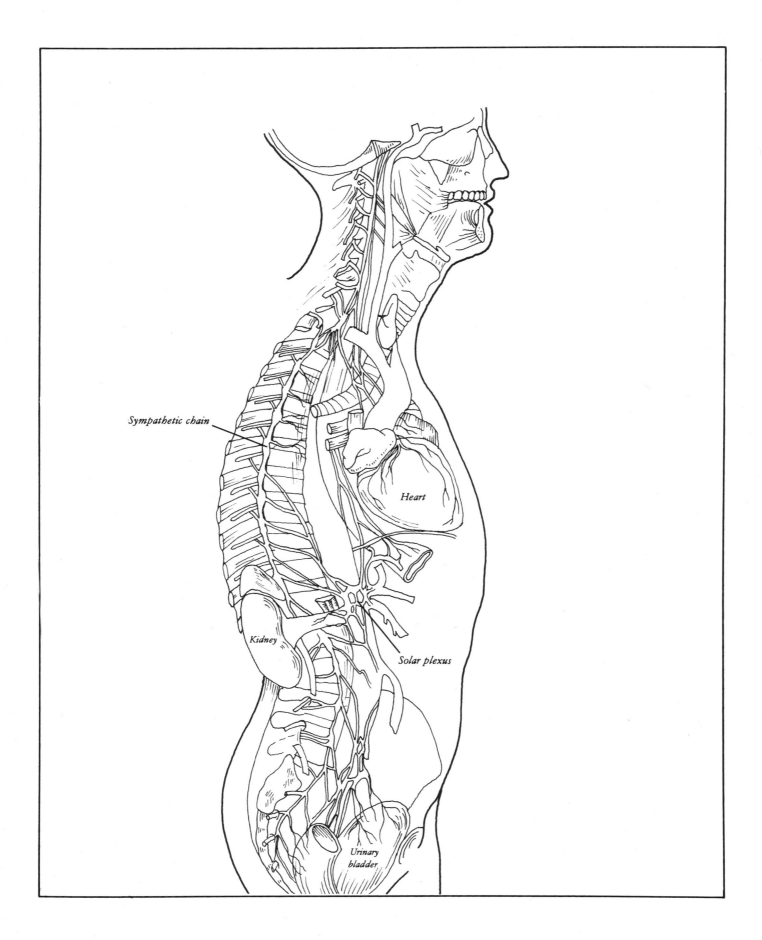

A side view, slightly off center, showing the main branches of the sympathetic nervous system. It controls such functions as pulse rate, respiratory rate, blood pressure, and many other body functions that we are not even aware of.

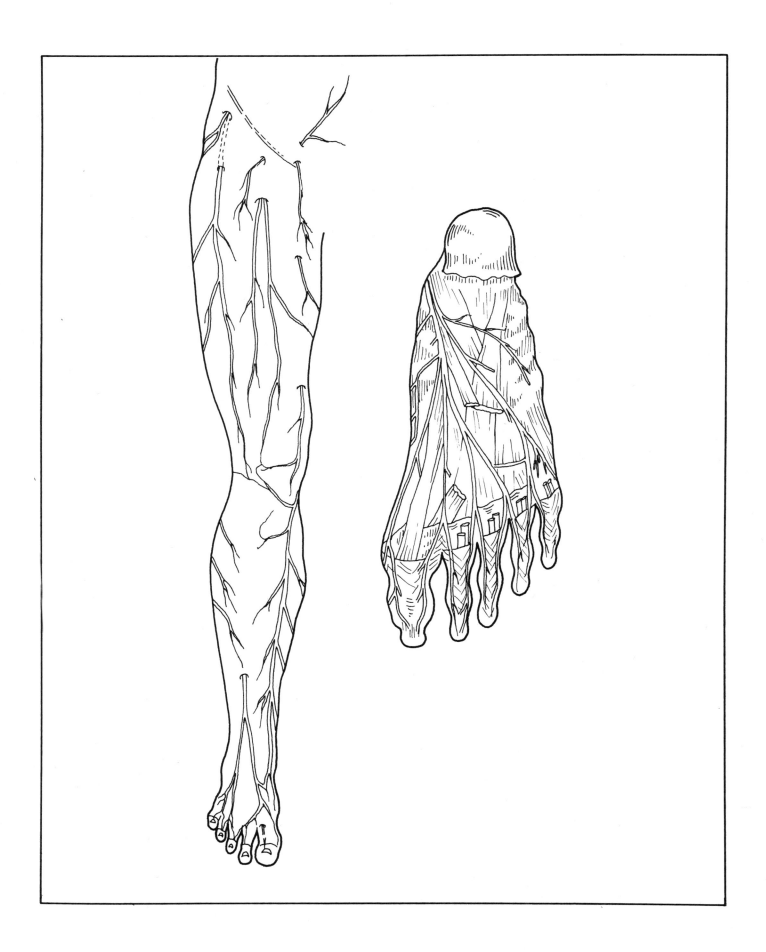

Left: The surface nerves of the right leg, seen from the front. *Right:* This is a view of the bottom of the foot showing the nerves that supply the skin and some of the muscles.

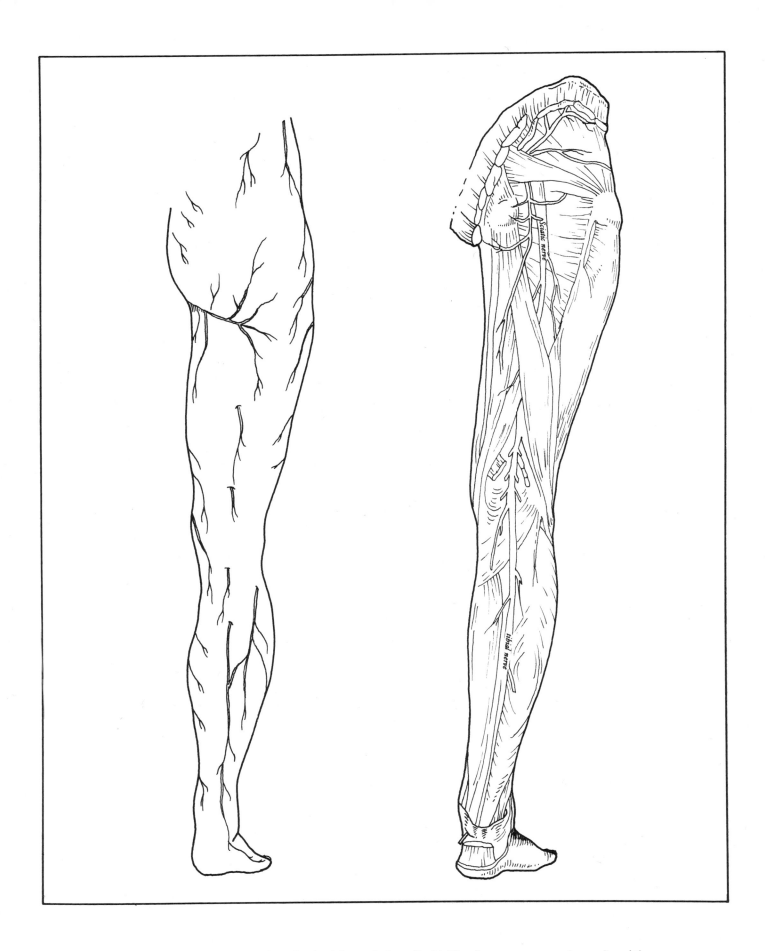

Left: The surface nerves of the back of the right leg. *Right:* The deeper nerves and muscles of the back of the right leg.

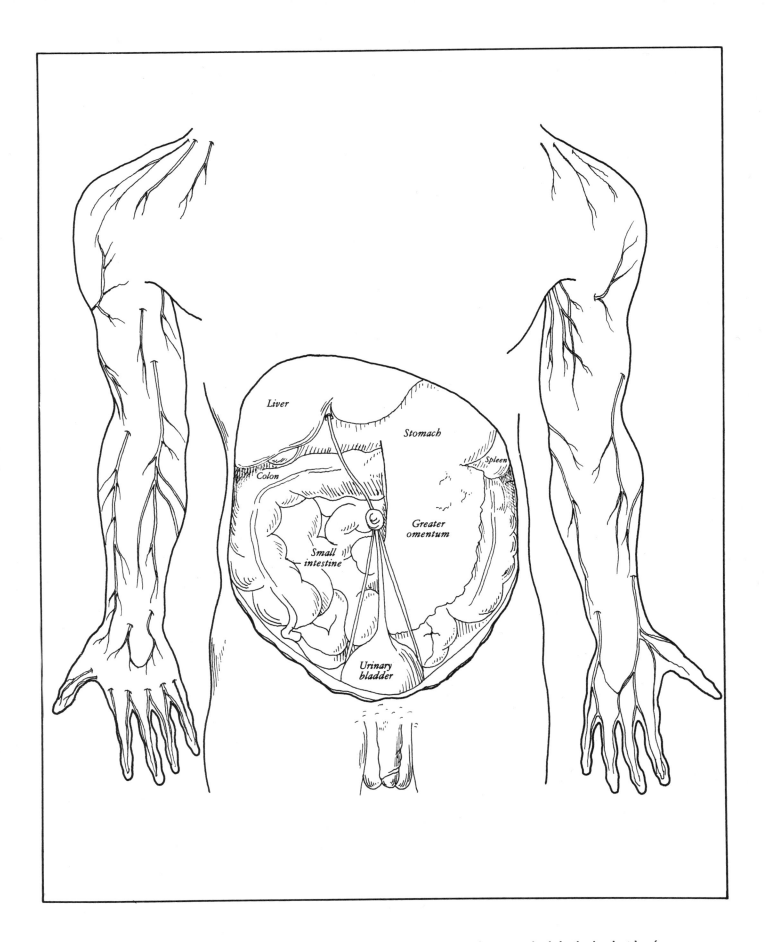

The surface nerves of the right arm. The front side of the arm is drawn on the left; the back side of the same arm is shown on the right. *Inside:* The regions of the abdomen, and the major organs in each region.

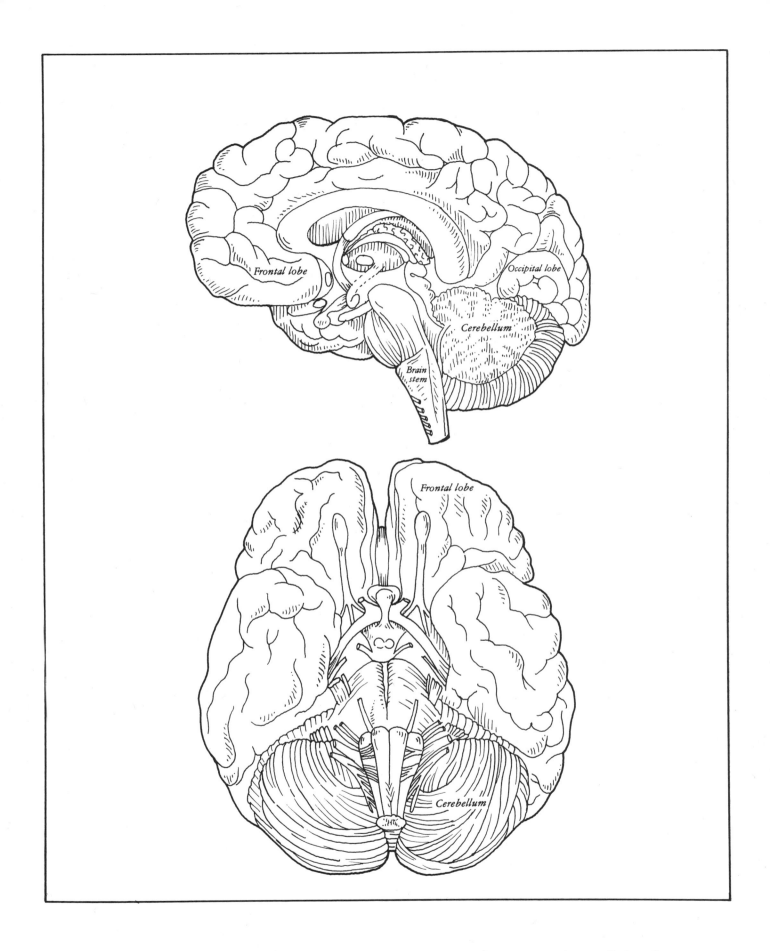

Top: The right side of the brain, seen as if it were cut down the middle from top to bottom. *Bottom:* A view of the brain from the bottom surface.

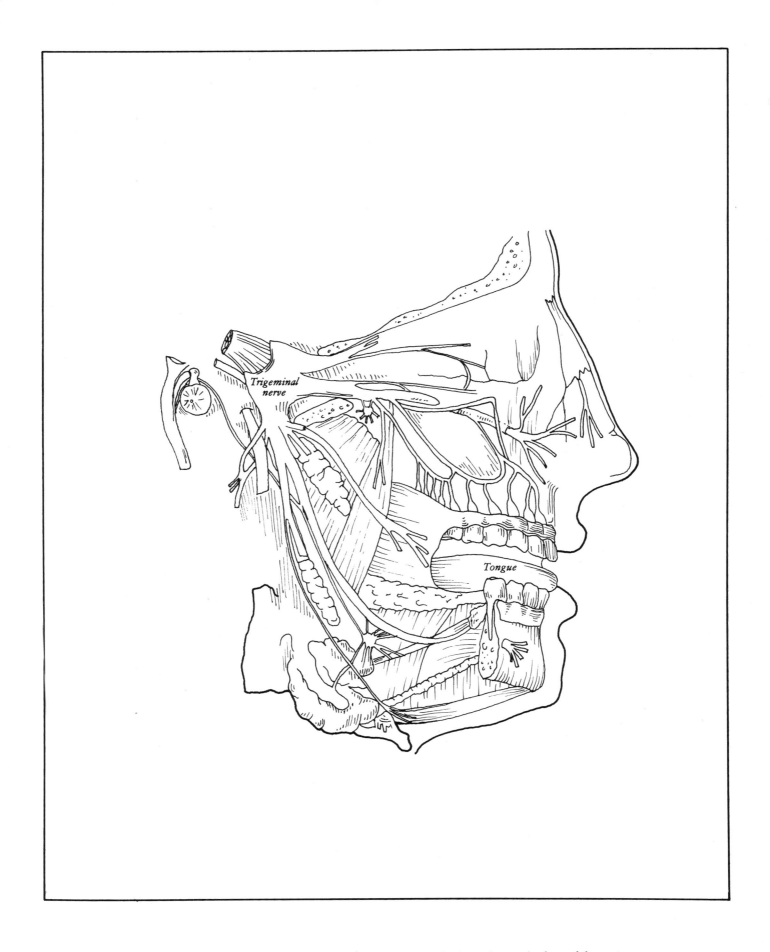

Trigeminal nerve

Tongue

This is a see-through view of the side of the head, showing the branches in the face of the main sensory nerve, which comes directly from the brain.

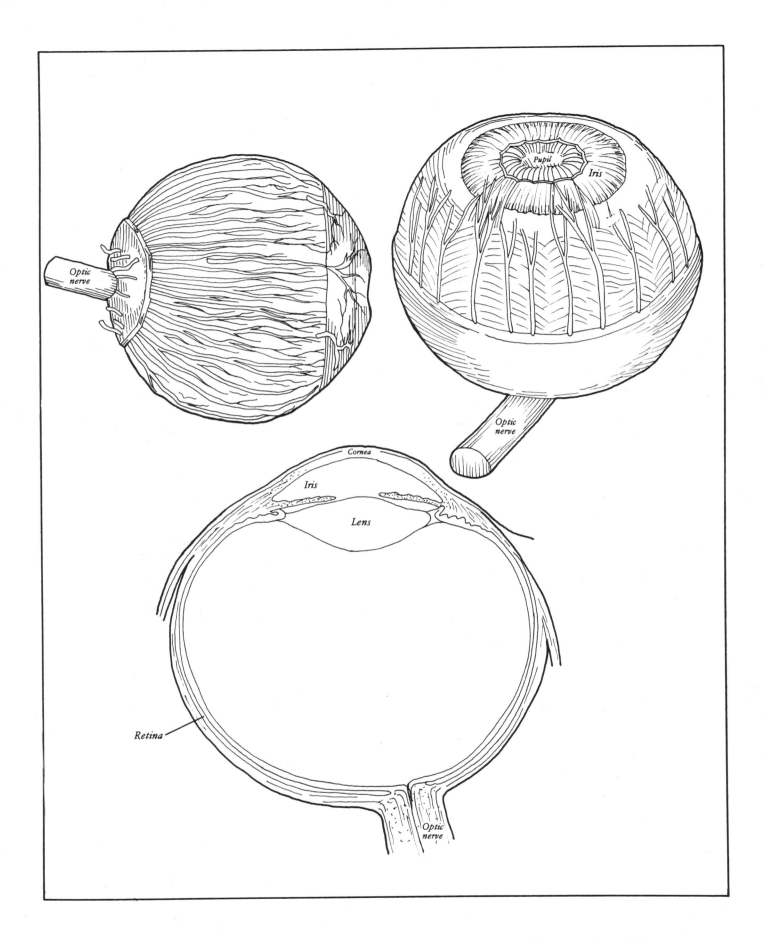

Three views of the eye. *Top:* In both front and side views, the whole globe of the eye is shown, but with the white layer (the sclera) removed. *Bottom:* The eye as if it were cut through the middle on a horizontal plane.

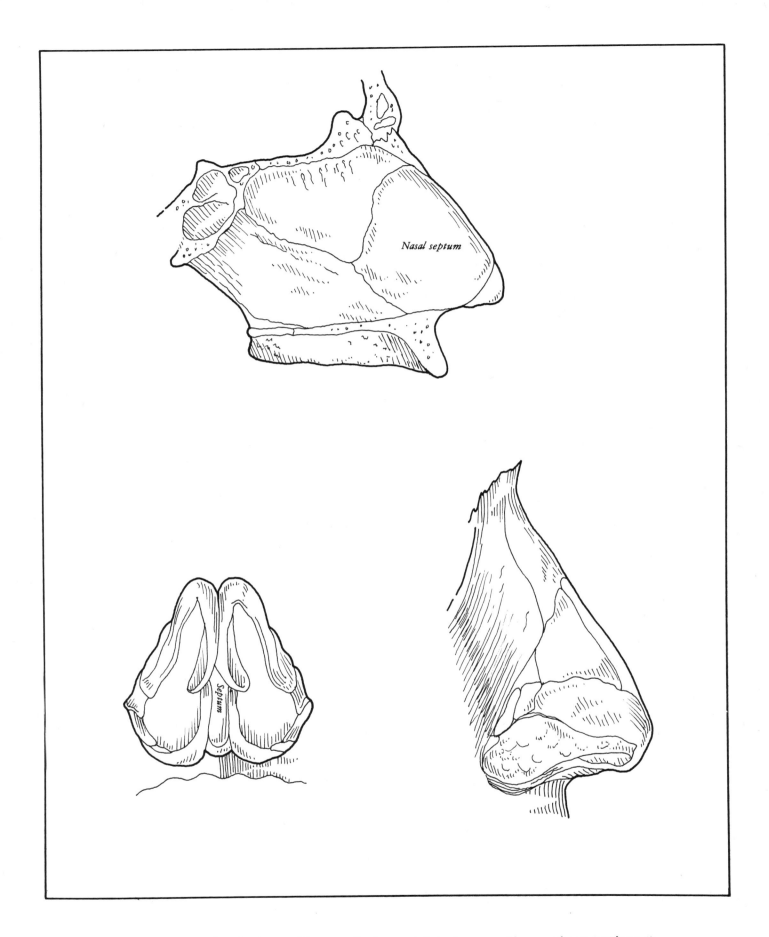

The nose. *Top:* The dividing wall between the two nostrils is shown; part bone and part cartilage, it is called the nasal septum. *Bottom left:* The septum and nostrils, seen from below. *Bottom right:* The outside of the nose, showing the cartilage and bone that make it up.

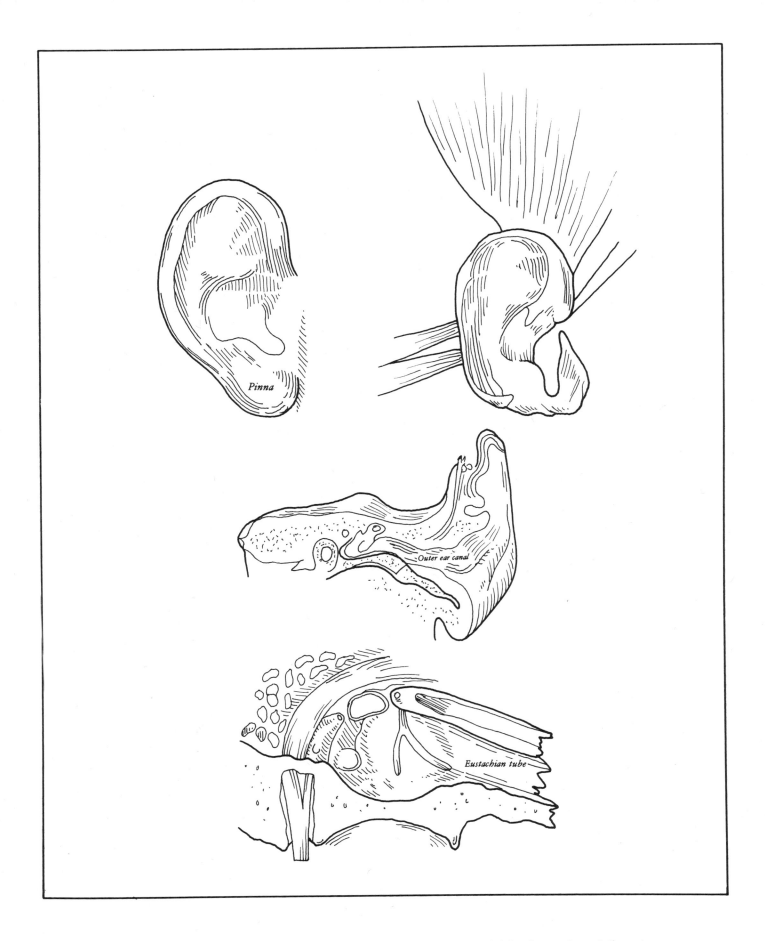

The ear. *Top:* The outer ear, or pinna, also shown with its muscles. *Middle:* A view through the outer ear canal and middle ear, showing the eardrum and the bony ossicles. *Bottom:* A view inside the middle ear, showing its internal wall and the Eustachian tube leading into it.

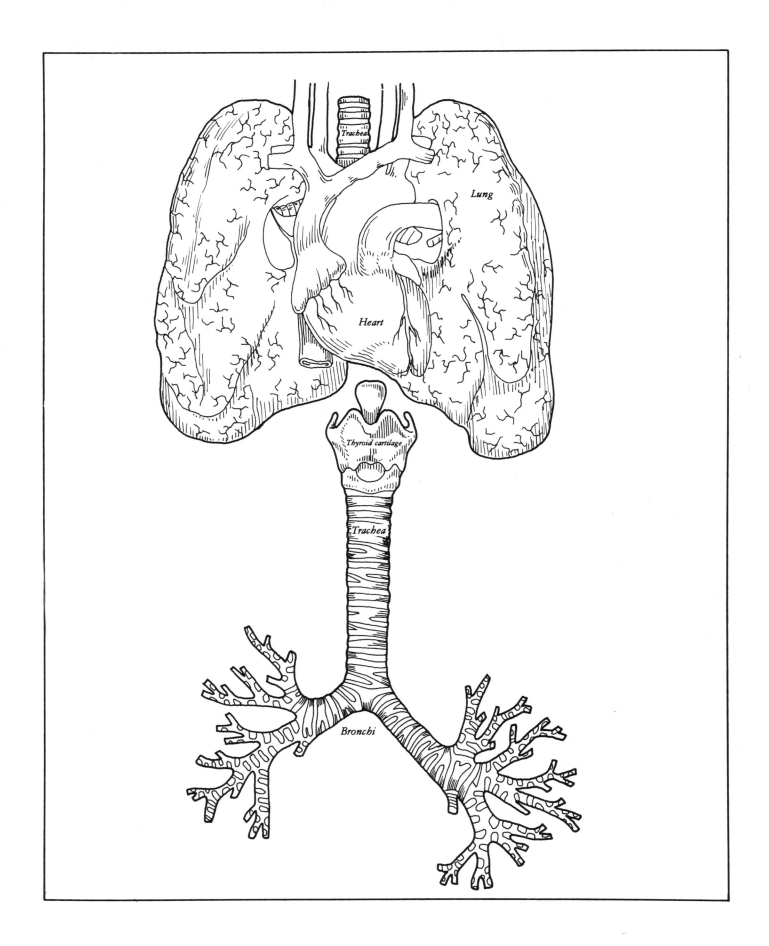

Top: The lungs and heart in a view from the front. The trachea is shown at the top. *Bottom:* The trachea and the bronchi—the "windpipes." Air travels through these tubes on the way to the lungs.

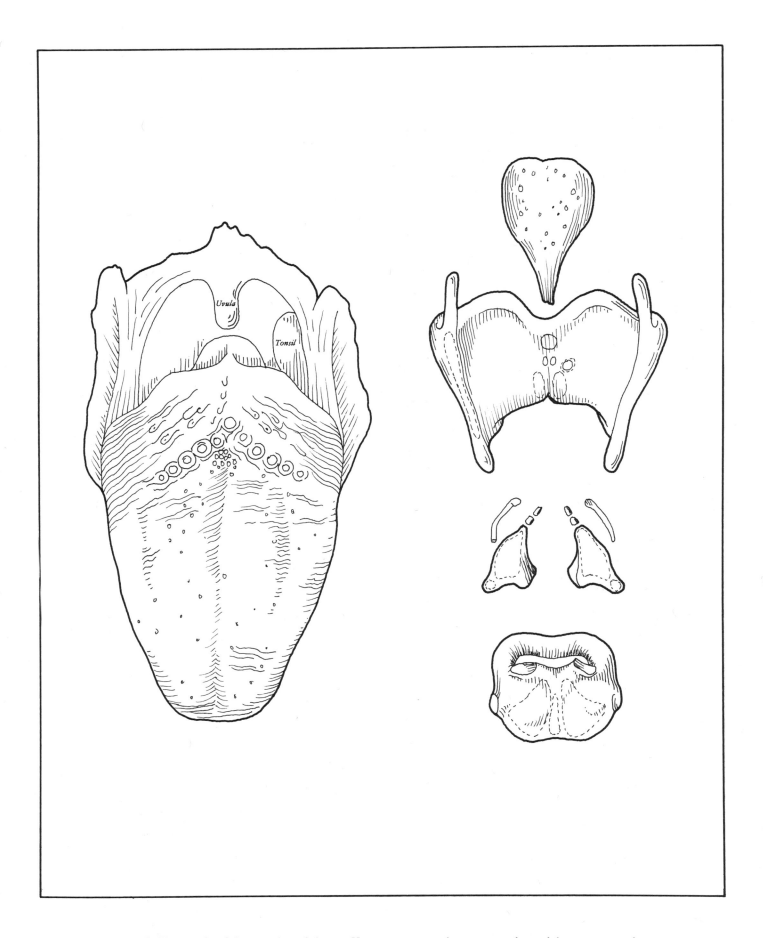

Left: The inside of the mouth and throat. Here we can see the entire surface of the tongue, with its prominent surface markings (papillae). Note the tonsil on the right. *Right:* The cartilages that go together to make the larynx, or "voice box." Here they are seen from the back.

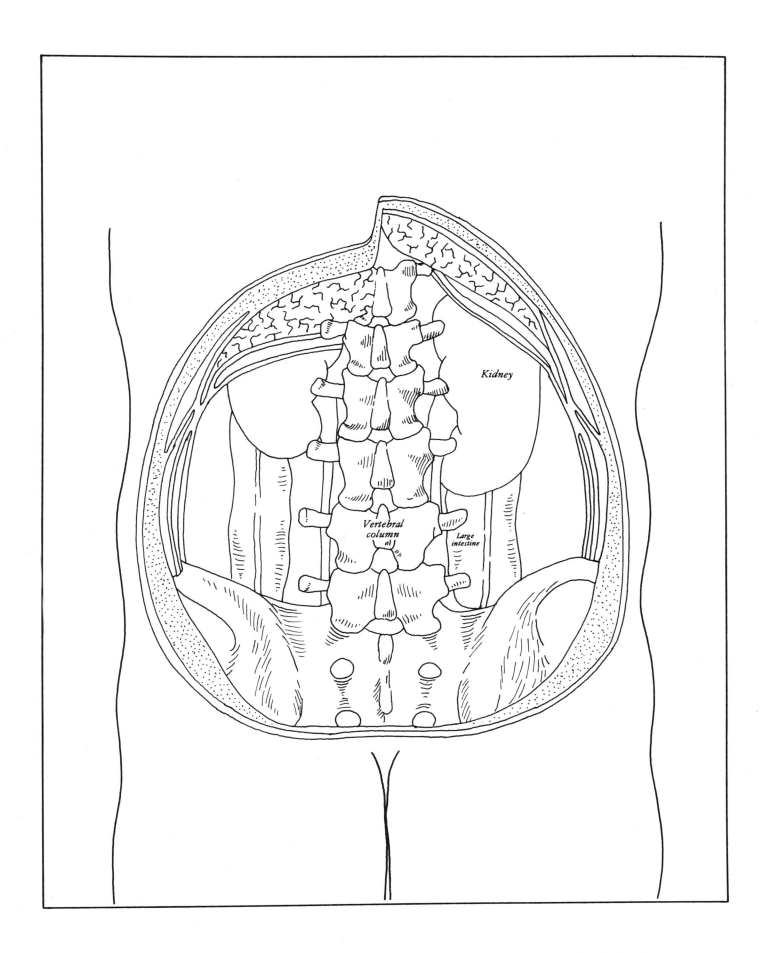

A view of the lower back vertebrae and some of the organs in the abdomen, as seen from the back.
The kidneys and large intestines are especially prominent.

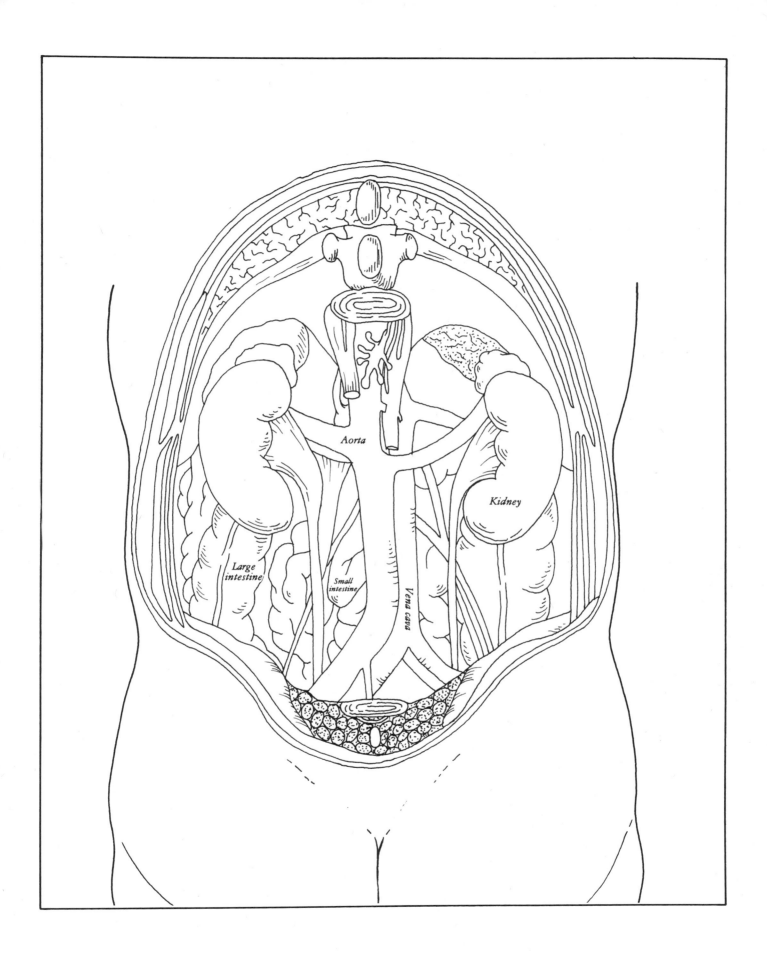

A view of the organs of the abdomen as seen from the back. The vertebral column has been removed to show the structures in the middle area.

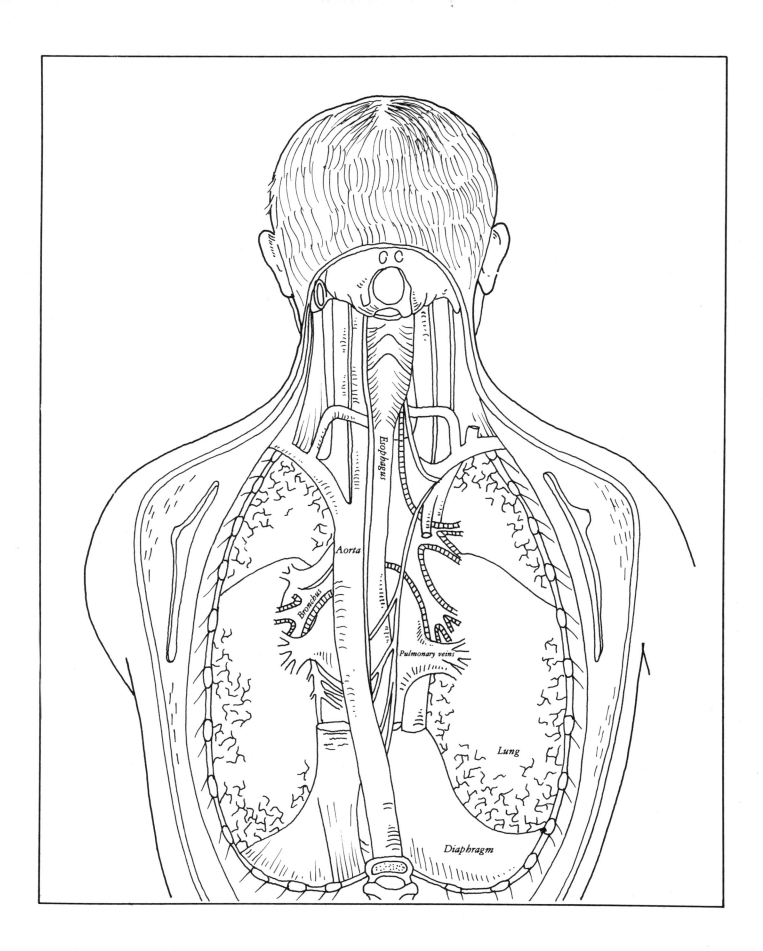

This is a view of the organs in the neck and chest, or thorax, as seen from behind.